contents

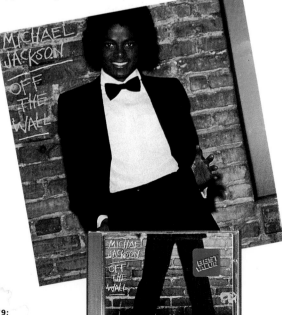

Off The Wall packaging.
Michael Jackson's breakthrough
smash: original album cover, 1979;
reissued compact disc, 1992.

seen

Long before there was a history of photography, there were histories written in photographs. Today, we take for granted that visual images constitute narratives of the past that, whether handed down within families or broadcast around the world, shape our understandings of the present and of ourselves. → But do visual images embed us within history, or do they simply leave a residue of styles that can be resurrected and redirected to suit the whims of the moment, the way the characters on *Melrose Place* don costumes (can you believe Sydney in white mini-skirt and go-go boots?) to signify their transformations from villians to victims and back? How photographs shape memory, how memory produces history, how history becomes fashion—these are questions at the core of much of this issue. Images that are redrawn from Abraham Zapruder's film of the Kennedy assassination, or uncovered from the archives of the genocidal Khmer Rouge regime, rebuke any notion that history is fixed and authoritative. Instead, we are shown a past that is fluid and contingent, willing and able to be shaped into narratives that are as likely to be idiosyncratic as informative. → History is much on our minds because see now has one: this issue marks the beginning of the second year of quarterly publishing. From your responses, we believe we have touched a nerve and found a need, placing photography in a context that connects it to culture as a whole instead of seeing it as a medium unto itself. This issue also marks a new era in our staffing: Editor Michael Read, whose creative touch and constant attention helped shape see from the start, has gone on to new endeavors. We will miss his editorial genius and good humor. The rest of us will continue to tend see's spirit as it evolves and metamorphizes into ever higher incarnations.
—Andy Grundberg

Elvis spotted frolicking on the lawn!

Having prepared a scrumptious feast for that special someone, it would hardly do to serve seared tuna with cilantro on plain old Corelle. No, you need to show off your good taste in contemporary photography by choosing plates adorned with images by the likes of William Wegman and Robert Mapplethorpe. These porcelain collectables are available from the Art Matters Catalog (New York, N.Y.). As the catalog points out in regards to the Mapplethorpe "Calla Lily" plate, "The depth and beauty of the black and white image make it equally suited for hanging or dining"—a versatility of use that the photographer himself certainly would have appreciated.

> We must acquire and use the benefits of new technologies, and must explore new corridors of thought and feeling.
> —Ansel Adams, 1982

Ansel Adams, Digital Genius Owners of such widely printed masterworks as *Moonrise, Hernandez, N.M.*, should take note of the following message: *Only such works authorized by The Ansel Adams Publishing Rights Trust and published by Time Warner Electronic Publishing/Little, Brown and Company can be considered authentic reproductions of the genius of Ansel Adams.*

The jejeune genius warning is found on the jacket of Time Warner's "Ansel Adams Screensaver," the latest diversionary software for computer users who like to dream of far-off landscapes while resting from the rigors of financial spreadsheets and word processing. The screensaver includes 38 Ansel Adams images and assorted

quotations from the photographer's writings. The photographs were commissioned by the government in 1941 and made into murals for the Department of the Interior—a circumstance that hasn't prevented the Publishing Rights Trust from placing its copyright notice on the box, jacket and instruc-

tion book. The screensaver also is said to mark "the first time Adams' work has been published in digital form," which discounts slightly the digital technology used to create the reproductions found in 1994's *Ansel Adams: In Color*, also from Little, Brown.

They say that Elvis worship is becoming the world's largest religion. Well, now you can wear your favorite boy-next-door-made-good from hip to toe, in vestiments proving your dedication to Elvis as the eternal icon of jailhouse rock and Vegas schlock. Photographs from all stations of Elvis' life—from young wild thing to movie star to caped crusader—adorn these tights, making the wearer a walking shrine to the King.

With so many of our cultures being made up of bits and pieces of other cultures, our sense of self becomes confused with our sense of the "others" who have joined us. The Parisian may long for an evening out at an African nightclub when visiting America. The Japanese visiting Burma may long for McDonald's or fresh spaghetti. Are our changing palettes a taste of what is to come? Will we eventually imagine ourselves as someone else and appropriate their history, their tragedies, their manners and foibles? Will our identities become so thoroughly confused that what once was our original "base" culture recedes to a dwindling remnant?

Modotti tags up *Roses,* a classic photograph by Tina Modotti, was an auction sensation when purchased by Esprit designer Susie Tompkins and a fashion statement when it appeared as the signature tag of Tompkins' eponymous adult clothing line. Was Modotti's life brief and tragic? Then so was that of the *Roses* tag, which passed away when Tompkins' line went defunct last fall.

We are they and they are we.

—David Byrne, *Strange Ritual* (Chronicle Books, 1995)

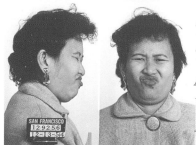

The new Police Act will take down each fact
That occurs in its wide jurisdiction
And each beggar and thief in the boldest relief
Will be giving a color to fiction.

—The third verse of a song dedicated to the inventor of the daguerreotype.

perspectives

BY DEBORAH KLOCHKO

A history of images and ideas

Mug Shots, Measuring and Motion

PHOTOGRAPHY PLAYED AN IMPORTANT ROLE in the evolution of criminology. Not only a scientific tool used for identification purposes, photography helped validate the nineteenth-century notion that criminal types were based on specific physical features.

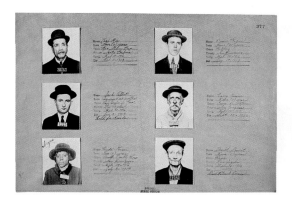

Within a few years following the introduction of the daguerreotype in 1839, the process was used to record the likenesses of criminals as a deterrent to continued illegal activities. **It was not uncommon for subjects being photographed to grimace, distorting their faces in an attempt to make themselves unrecognizable.**

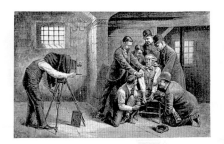

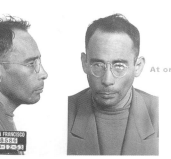

San Francisco was one of the first cities in the United States to make photographic mug shots as early as 1854. However, not until 1874, in France, was the first police photographic laboratory created.

At one time, ears were thought to be extremely useful for criminal identification.

By the early 1880s, the Frenchman Alphonse Bertillon created a new system of criminal identification that included detailed body measurements, a physical description and a front and side view standardized photographic portrait of each criminal (still in use today). This new system relied on **anthropometry**, helping to establish a new scientific approach to police work quickly popularized worldwide, and causing Bertillon to be known as the "father of scientific detection". Within a decade, the Paris police department accumulated more than 100,000 photographs.

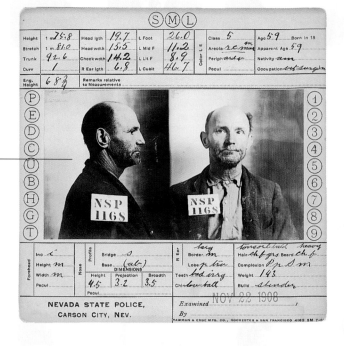

Anthropometrical (*anthropos* Greek for *man*, and *metrikos* Greek for *measurement*)

Fig. 2

Special thanks to the Fraenkel Gallery, Charles Hartman, the collection of Heather Shapiro, and Kean Wilcox.

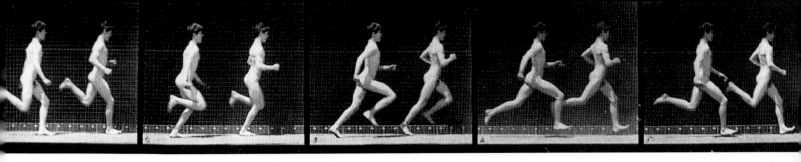

Experimentation is a type of question applied to nature in order to make it speak.—Bacon

By the mid-nineteenth century, scientists considered photography an unbiased tool for recording and documenting the world. The study of facial features and expression, known as **physiognomy**, was a means of judging character and mental abilities based on outward appearance. The photographic **evidence** of racial types, emotions and facial expressions was influential in the creation of police mug shots.

The biological sciences also included the study of movement. In 1878, Eadweard Muybridge, already a successful landscape photographer, began his pioneering experiments in sequential photography. For the first time, stages of motion that could not be seen by the human eye were captured on film.

The novelist L.P. Hartly wrote,

"The past is a foreign country;

they do things differently there."

Is the past really so different ?
The mug shot still is used today, though the means of disseminating this visual information have been expanded.

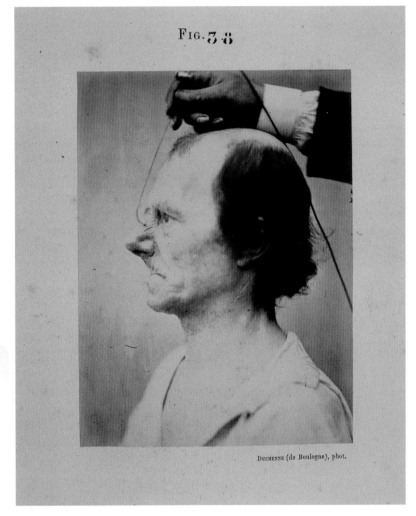

FIG. 38

DUCHENNE (de Boulogne), phot.

In the 1860s, Dr. Guillame Benjamin-Armand Duchenne, the founder of **electrotherapy**, utilized photography to more accurately illustrate his research. Duchenne was interested in using electricity to simulate emotions.

On widely syndicated television programs such as *America's Most Wanted,* mug shots are brought to life through dramatized reenactments of the suspects' crimes.
Viewers are simultaneously entertained and empowered by this technological, mass-media attempt to apprehend criminals with the help of visual images. ☼

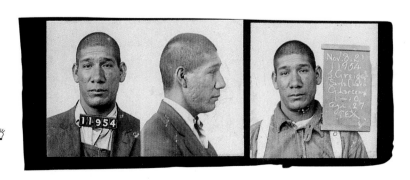

Join us

The Friends of Photography

And enjoy . . .

Four issues of see, a journal of visual culture

Ten percent off any book or merchandise available from The Friends of Photography Bookstore, in person or by mail

Collector print program: Members at the Sustaining level and above participate in our annual Collector Print Program. Artists featured in 1996 are Tina Barney, Christopher Bucklow, Nan Goldin, Stephen Johnson, Helen Levitt, Frederic Ohringer and Fazal Sheikh

Free admissions to the Ansel Adams Center for Photography

Members' receptions, special events and gallery talks at the Ansel Adams Center for Photography

Seminars, classes, and lectures

Reciprocal benefits at eight photography institutions across the United States

Participation in The Friends' annual Members' Portfolio Review

Frederic Ohringer, *Labios Ardientes, Rain Forest, Costa Rica*, 1993. Sepia toned gelatin silver print, 6 5/8 by 6 5/8 inch image on 8 by 10 inch paper. Courtesy of the artist, Ursula Gropper Associates, San Francisco, and the Houk/Friedman Gallery, New York.

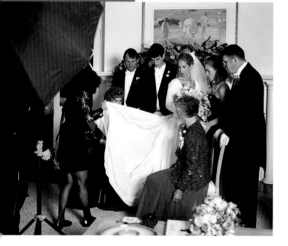

Tina Barney, *The Wedding Portrait*, 1993. Chromogenic color print, 11 by 14 inches. Courtesy of the artist and Janet Borden, Inc., New York.

Support The Friends' programs in Education, Exhibitions and Publications

For more information about membership, contact:
The Friends of Photography
250 Fourth Street
San Francisco CA 94103
Phone: 415.495.7000
Fax: 415.495.8517
E-mail: seefop@aol.com

Nan Goldin, *The Honda Brothers on the Street, Tokyo*, 1994. Dye destruction print, 11 by 11 inch image on 11 by 14 inch paper. Courtesy of the artist and Matthew Marks Gallery, New York.

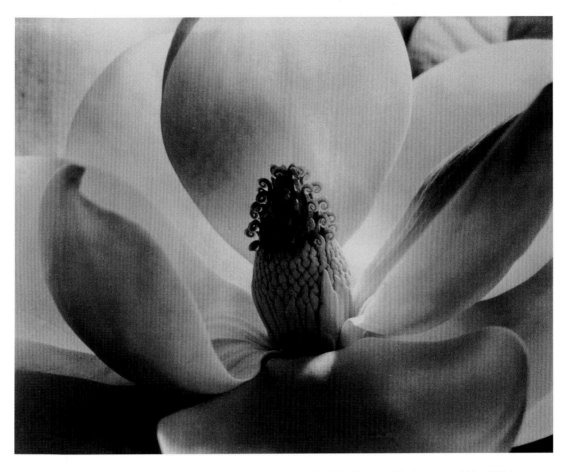

FINE ART AND

PHOTOGRAPHS

SINCE 1970

LYNN
BIANCHI

WORKS ALSO AVAILABLE BY:

JOEL-PETER WITKIN

BEN SCHONZEIT

SANDY SKOGLUND

EBERHARD
GRAMES

TODD WATTS

JAMES CRABLE

ROBERT MAPPLETHORPE

MISHA GORDIN

AND OTHERS

LISA
GRAY

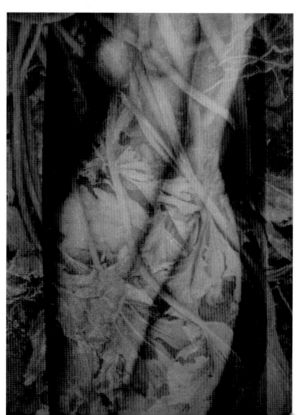

669 MISSION STREE

SAN FRANCISCO, CA 9410

415 546 100

J.J. Brookings Gallery

Fine 19th and 20th Century Photographs

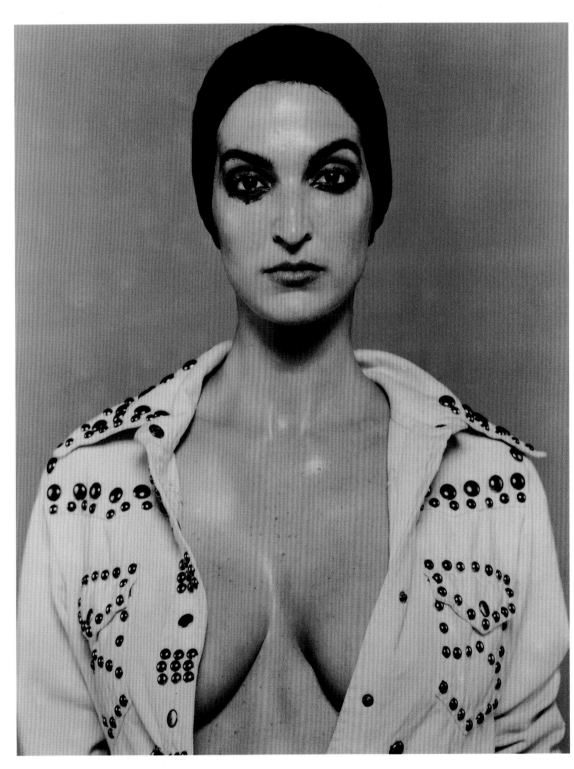

Bettina Rheims, "Carol W.", 1990 41 1/8" x 43 1/4" Gelatin Silver Print, Mounted on Aluminum

FIVE STUDIES FROM AN ENDLESS FILM

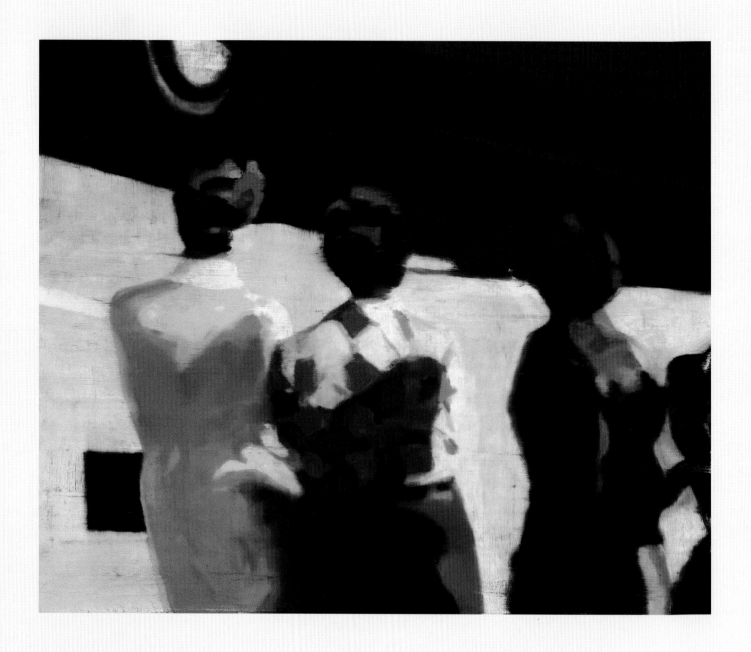

CHRISTOPHER BROWN

see **12**

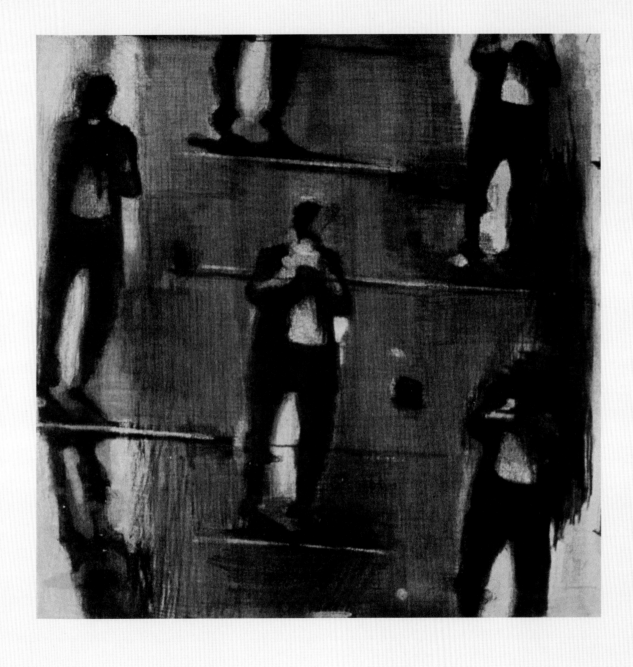

Multiple, 1994.

Facing page: *Instant,* 1994.

see **13**

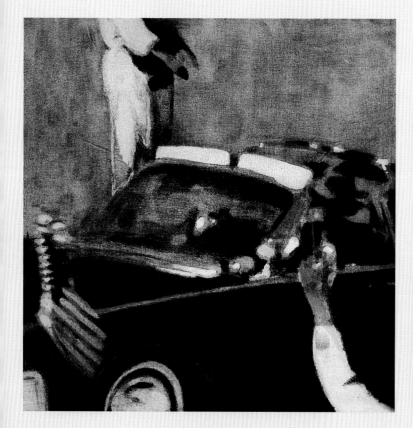 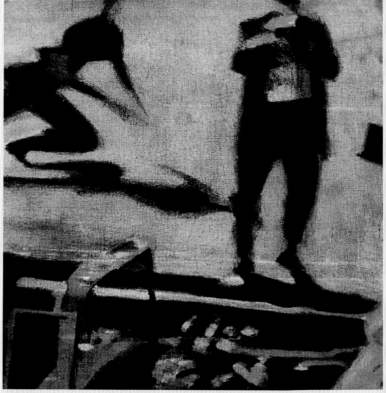

Above left: *Flag,* 1994.

Above right: *Runner,* 1994.

Facing page: *Continental,* 1994.

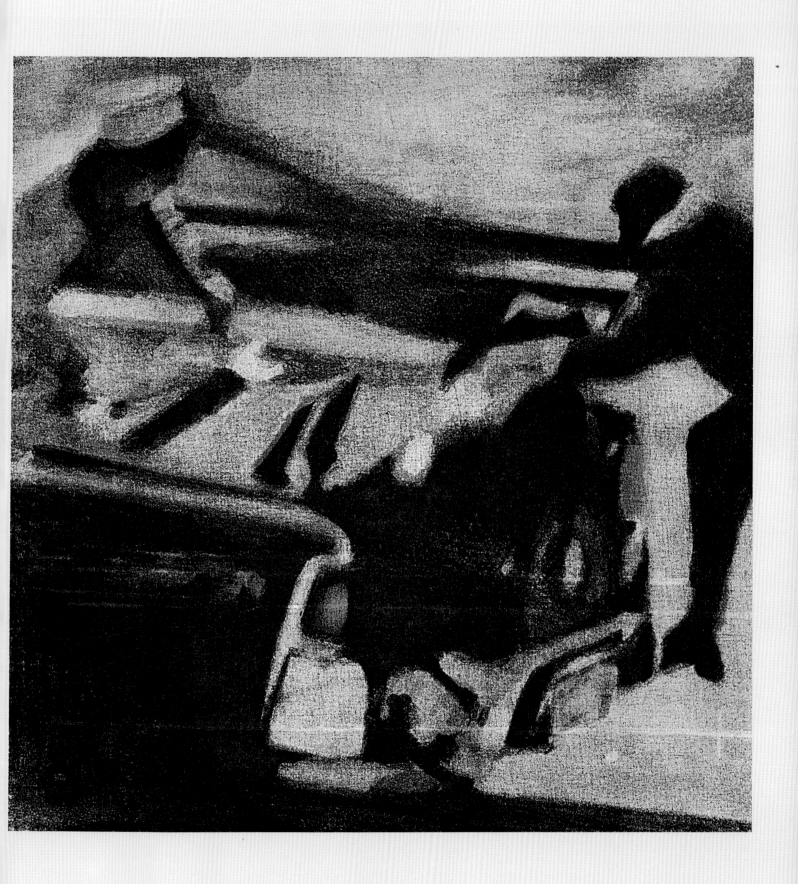

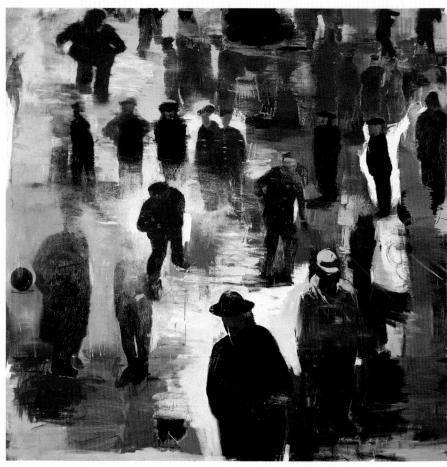

November 19, 1863, 1989.

Photographic
Memory

BY LEAH OLLMAN

IT'S THE LANGUID POSTURE of the woman on the left that so haunts and disarms. The slight sway of her hip registers no tension, no recognition of what the moment holds. The woman in the middle stands stolid as a tree, equally unmoved. They wait and watch, while the woman on the right twists forward, it seems, with a jerk of comprehension. We know what they are about to see. They soon will witness one of the crimes of the century, and because we know what they cannot, we study them in awe, scrutinize their postures and surrender to a peculiar nostalgia. We watch them hover in benign innocence, on the threshold of loss.

Christopher Brown's 1994 painting *Instant* recreates a fragment of a film frame of John F. Kennedy's assassination, recorded by bystander Abraham Zapruder. The image, and others Brown has painted and etched using the Zapruder footage, gnaws relentlessly at a raw spot in the memory. Whose memory?

> *History...is a good solid subject, but we can print most of the facts on one flap of the jacket.* What *happened and* where *is history—how and why it happened is fiction. If it is good fiction we accept it as history.*
> —Wright Morris [1]

The notion of a photographic memory is not as freakish as it may at first sound. We all have one—not a pristine archive of flash-frozen details, as mythologized in detective stories and magic shows, but a real, poorly-filed mental catalogue of images. Memory is by nature photographic, fueled by the accidental, the incidental, the coincidental, tempered by style and will. The photographic recording system operates much like the mental one. Both are heavily mediated but presumed to be pure, inescapably selective and fragmented… but, more often than not, trusted.

However much [photographs] may lie, they do so with the raw materials of truth.—Wright Morris [3]

Photographs, Morris says, are snipped from living tissue. So too are memories. Both bear the irresistible, seductive aura of the authentic. We yearn for that connection, that affirmation and validation of experience or learning or hearsay that memories and photographs provide. But photographs have the edge: they can be made public, while memories, in their most potent form, remain private.

The idea of the camera has so implanted itself that our very imagination of the past takes the snapshot as its notion of adequacy, the equivalent of having been there. Photographs are the popular historicism of our era; they confer nothing less than reality itself.
—Alan Trachtenberg [4]

Public memories. Photographic images. From experience to image to memory to history. How did a painting bring us here?

In making a painting, I'm trying to reinvent the kind of mystery that is my own fascination with a photograph.—Christopher Brown [5]

There have been paintings before Brown's that mimic photographic vision, but none that I know bring me closer to the conflicted soul of the medium, its twin claims on the personal statement and the impersonal

document, its chemically certain yet tenuous link to reality, its authenticity—not in absolute terms, but from the perspective of the one who was there, who held the camera.

Christopher Brown began using photographic imagery from the civil war in his paintings in the late 1980s, after many years of collecting and studying photographs. Even when he is not quoting or translating from specific images, the idioms of photography permeate his work: blurred figures, abrupt cropping, flattening of space.

pening, but I don't have the advantage of knowing what it is. It's the same as the sensation of looking through binoculars. You get the details but you miss the larger context. That's life. You can't have it both ways. [7]

The men mill about. One bends down, another turns to the side. Some wear uniforms the color of blood. Some dissolve in the glare of intense golden light. A cannonball hovers, off to one side. There is detail, and

In making a painting, I'm trying to reinvent the kind of mystery that is my own fascination with a photograph.—Christopher Brown

In the blur of the photograph time leaves its gleaming, snail-like track.—Wright Morris [6]

The rapturous, sensual immediacy of Brown's paintings vivifies these traces of time's passage. Experience, learning and memory layer upon one another—much as in that richly ambiguous phenomenon we call life. Or photography. Ambiguous and uncertain, but we trust. We are vulnerable to the spell of authenticity, its scent, its surface, and our eyes affirm that what we see is, or has been, real.

Trust?

We trust representations all the time, even as they unbraid the internal logic of the subjects they describe. They fragment, they distort; these are the natural laws of painting, but only the implicit ones of photography and memory. Brown crowns contingency as the ruler of them all, not to unsettle and undermine as much as to defeat the assumption that we can possibly understand where we are or where we have been. The women in *Instant* are stand-ins, surrogates for our own witnessing. They have the advantage of direct experience—the details—while we have the privilege of context, the omniscient, wide-angle view.

November 19, 1863, one of Brown's paintings based on Civil War-era photographs, offers a corollary to the distanced perspective we have on history, a view from the inside. As Brown explains:

That's how I feel, being in the middle of it all but not understanding what's going on. There's a great thing hap-

there is confusion. The air is portentous, the scene mundane. It's an ode to what Brown describes as "the impossibility of ever knowing the world, capturing the particularity of it and the enormity at the same time."

It's an idiosyncratic, soulful homage to the mysteries of photography. It's a thoroughly modern history painting in the way it unravels the conventions of absolute knowledge. And to Brown, it's a self-portrait. ✣

NOTES

1 Wright Morris, "About Fiction," *Time Pieces: Photographs, Writing and Memory* (New York: Aperture, 1989), p. 104.

2 Michael André Bernstein, *Foregone Conclusions: Against Apocalyptic History* (Berkeley and Los Angeles: University of California Press, 1994), p. 47.

3 Wright Morris, "The Camera Eye," *Time Pieces: Photographs, Writing and Memory* (New York: Aperture, 1989), p. 14.

4 Alan Trachtenberg, "Albums of War: On Reading Civil War Photographs," *Representations*, No. 9, Winter 1985, pp. 1-32.

5 Christopher Brown, from a conversation with the author, 16 August 1995.

6 Wright Morris, "Time Pieces," *Time Pieces: Photographs, Writing and Memory* (New York: Aperture, 1989), p. 42.

7 Christopher Brown, from a conversation with the author, 16 August 1995.

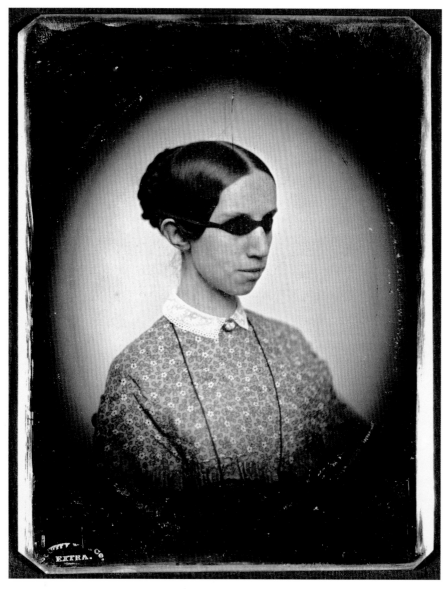

Southworth and Hawes, *Laura Bridgman, Blind Poet*, ca. 1850.

The history of photography comes at us like a cascade of images—images of houses, heroes, corpses, workers, landscapes, trees, the Eiffel Tower being struck by lightning, statues—a deluge that threatens to drown us. Within that cascade can be isolated currents of images that are the history of genres and themes; within these run still narrower streams or sometimes only trickles of images that appear and disappear throughout this torrent. One such trickle that has long engrossed me is that of photographs of the blind. It begins famously and early with Southworth's and Hawes' daguerreotype of Laura Bridgman, usually subtitled "the blind poet." Like most subsequent portraits of the blind, it also is a portrait about the horizon of the visible—the point at which sight reaches its limits and the world extends beyond it.

Because photography is the most purely visual of the visual arts—its making depends more on the eye and its mechanical accoutrements than on the hand that draws, paints, sculpts—these photographs of the blind constitute in some ways a secret exploration of photography itself, its scope and confines. Blindness of a sort is itself a crucial aspect of the photographic process: the impenetrable darkness in which the unexposed film must exist in containers and cameras, the religious dimness of the darkroom lit only by a safety light, the pitch black in which one spools film onto developing reels, and the lapse of time between making and seeing a photographic image (save, of course, Polaroids). Photographers—at least those who do their own darkroom work—are among the few modern people who see true darkness, and in some sense the contemplative time of photography, as opposed to the active time, is the time of darkness. It is this time of darkness that the photographs of the blind begin to approach.

In the Bridgman portrait, the poetess sits in three-quarters profile in a print dress with lace collar, and with a shaped blindfold over her eyes—a means of preventing us from seeing her blindness directly—that looks almost like an ancestor of Ray Charles' wraparound sunglasses. But she sits in a halo of light. Hers is a portrait of a world in which visuality is powerless and the gaze sinks into a darkness rather than being returned. It intimates something that only will be fully real-

Because photography is the most purely visual of the visual arts—its making depends more on the eye and its mechanical accoutrements than on the hand that draws, paints, sculpts—these photographs of the blind constitute in some ways a secret exploration of photography itself, its scope and confines.

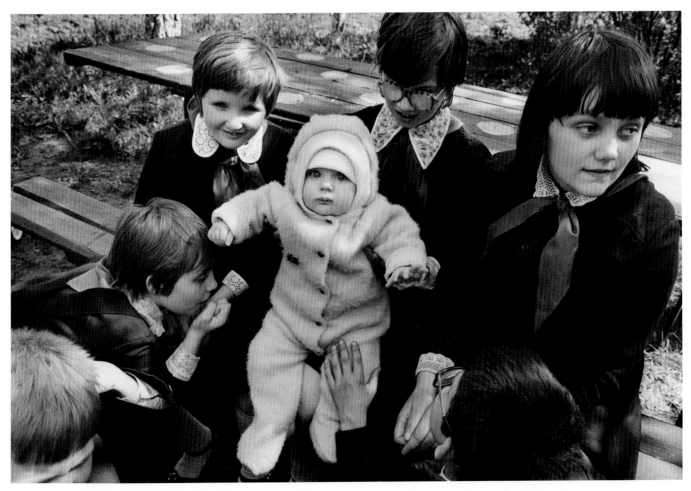

Mary Ellen Mark, *Blind Children with Sighted Baby at the Special School for Blind Children No. 5, Kiev, Ukraine, USSR*, 1987.

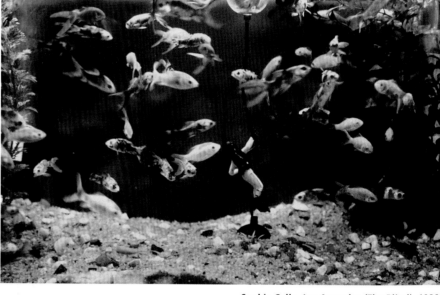

Sophie Calle, *Les Aveugles (The Blind)*, 1986.

ized later in photographs of the blind—as images of a world that denies images, as a visual representation of the boundaries of the visible, as an encounter with photography's own negation. After Bridgman come many isolated images, from Paul Strand's *Blind* to Diane Arbus' portrait of a stately Jorge Luis Borges standing, or wavering, in the park after he had lost his sight. Lisette Model pursued the subject in the 1930s and '40s with portraits both of the itinerant blind on the streets of Paris and of workers at the Lighthouse for the Blind. But the subject comes into its own in the last decade, with Sophie Calle's *Les Aveugles* (The Blind) of 1986, Mary Ellen Mark's 1987 photographs at Special School for Blind Children No. 5 in Kiev, and Nicholas Nixon's 1992 portrait series from the Perkins School for the Blind in Massachusetts.

Mark too has worked at Perkins and seems fascinated by blindness, for the subject also crops up in her photographs of India and elsewhere. But it is the photographs of children in Kiev that form the core of her investigation of their particular subculture—one that, like the circus performers she often photographed, says something about the nature of portraiture. For the difference between portraiture and other forms of representing peo-

ple lies in the relationship between photographer and subject, specifically in the latter's acknowledgment of the former, which makes the image something of a collaboration. This collaboration is present as the pose, the face the subject chooses to turn to the camera. With that turn and that choice, the solitary act of making a photograph becomes a social one. The daguerreotype collector Robert Shimshak once remarked to me that one of the things he likes about this first rush of portraits is that they are portraits of people before they had learned to pose; there is a naked candor in

them that will evaporate with daguerreotypy itself. Just as the Indian circus performers make the theatrical, performative nature of the contemporary portrait apparent, so the blind make the nature of the pose evident, by its absence, in these images of mutual solitude. Portraits of the blind are largely portraits without poses.

Usually in a photograph the implicit center of attention is the photographer, at whom the subject looks or from whom the subject looks away, for whom the subject poses. In portraits of the blind, however, the face is a completely different organ of sense, one that points according to another set of rules; the straight-on gaze is never encountered. Thus the photographer, and by extension the image and its viewers, are never acknowledged.

These photographs of the blind turn the tables, for though their subjects first of all are the kind of conveniently institutionalized, unusual types that photographers so often choose, they also are subjects who shift the power of the gaze.

see **20**

In one of Mark's Kiev photographs, three children sit in the foreground of a grassy field. At the right a handsome boy kneels in shadowed profile; in the center a girl in the dark uniform with lace cuffs worn by all the girls in the school faces toward the right, smiling; and at the far left of the frame another girl lifts her face, though her attention seems caught not by the light or warmth on her face but by the dandelion flowers in her hand. It is a portrait of three worlds in one photograph, and the blades of grass seem to measure extraordinary distances in a field of profound stillness. In another image the same smiling girl appears, this time with several others around a baby in white, like dark petals around a pale center. Usually, we would identify with the older children, with those who have the powers of reason and speech, yet here they are absorbed in touching the baby and each other—in a world knit together by the tactile rather than the visual—while the baby stares straight at us, or at the photographer, our stand-in. It's odd, but we find ourselves identifying with the baby. The image determines our identity as visual rather than rational or communicative, which is to say that in photographing the blind, the artists question not the world of blindness but the world of sight and our identification of consciousness with the ability to see.

Visual theory of the last decade has tended to focus on the pleasures and powers of looking, and almost without exception tends to suggest that if to see is to have power, to be seen is to be exploited (remember the male gaze?). These theories never acknowledged that if artists' work originates in looking, it culminates in being seen, or regarded or recognized (to use two synonyms with positive connotations). Artists and visual people in general tend to be moved by both desires; thus, the successful artist is one whose work is seen, so that his or her own gaze out into the world is confirmed by the attention of others. These photographs of the blind turn the tables, for though their subjects first of all are the kind of conveniently institutionalized, unusual types that photographers so often choose, they also are subjects who shift the power of that gaze. They remind us of a desire to be seen and acknowledged, and they remind us by its very absence.

Continued on page 69

Nicholas Nixon, *Jamie Watkins, Perkins School for the Blind,* **1992.**

CONVERSATIONS

Documentary Lacunae

with Peeter and Eve Linnap

IN NOVEMBER 1995 PEETER LINNAP, a photographer, curator, teacher and critic from Tallinn, Estonia, traveled to San Francisco for a five-week residency at the Ansel Adams Center for Photography, under the auspices of the ArtsLink, a program of the Citizens Exchange Council. While at the Center, Linnap and his wife, Eve, who also is a photographer, assembled an extensive slide library to bring back thousands of otherwise unavailable images to colleagues and students in Estonia, a Baltic country that until five years ago was part of the Soviet Union. He also spoke to students and other audiences about his work as an artist and as an advocate for contemporary photographic practice, and he gave a gallery talk about the exhibition *Points of Entry: Reframing America.*

Andy Grundberg and Deborah Klochko spoke with the Linnaps in the galleries of the Ansel Adams Center, where *Reframing America* was being shown. The exhibition focuses on European emigré photographers of the 1930s, '40s and '50s: Alexander Alland, Robert Frank, John Gutmann, Lisette Model, Marion Palfi, and Otto Hagel and Hansel Mieth.

DEBORAH KLOCHKO: Because *Reframing America* deals with outsiders, people from other countries looking in on America at a very specific time, it seems to set the stage for our discussion. In the gallery talk you recently gave, Peeter, you brought a very interesting perspective to looking at this work—in some ways as engaging as what the photographers themselves had done.

ANDY GRUNDBERG: The thing that struck me about your talk was that you described Alexander Alland's pictures as a melange of the styles that were available to him at the

time, and you mentioned that he managed to encompass both a machine-age aesthetic rooted in Constructivism—and later adopted by capitalism—and a form of Socialist Realism that developed in the Soviet Union more or less in reaction to Constructivism.

PEETER LINNAP: Yes; I said that several of Alland's images lead me to think of examples of Soviet Socialist Realism, because of the stylistic canons involved.

AG: You also spoke about documentary as a kind of style, and how we have become aware that it is a very encoded way of looking at

things. Your comments about Alland made me think that you have an acute suspicion of the documentary style. Does this suspicion stem from your critical thinking, or from having lived in a Baltic republic that was dominated by Soviet culture for most of your life?

PL: Actually, in a way I admire the first decades of the Soviet Union; it was very utopian, and I feel somehow sorry that it went the way it did in the Soviet Union. But I wanted to set up a question: did the photographers presented in the exhibition really reframe American photographic discourse

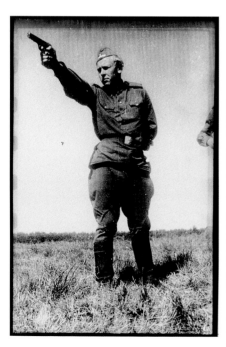
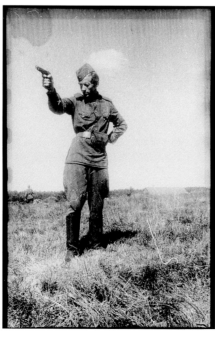
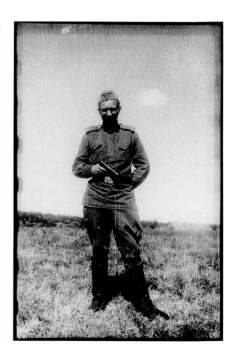

Peeter Linnap, from *SUMMER 1955,* 1993.

see **22**

or an American way of seeing, or is the exhibition simply presenting earlier historical styles filtered through their own language? Is it an exhibition writing the history of American photography, or a social history? That's something I haven't solved yet.

AG: Certainly these photographers came to America with an awareness of class, racism and fascism, therefore their attention to those things in American life marked a new way of looking at the country. Are you pondering if it is the individual achievement of these photographers to be aware of the country's mid-century social and political problems, or if their work merely reflects a broader tendency in that era's literature and arts?

PL: Well, I've dealt with the history of photography much more than with the geography or history of different countries, so I cannot say for sure. America for me, before I came here, was mostly the history of photography. My picture of America has been built from photo history, particularly *The Americans* by Robert Frank and early travel photographs by Jackson and O'Sullivan.

AG: Does that make it peculiar actually to be here?

PL: It makes it more interesting. What we see is measured and estimated against these photographs.

AG: Unless you're alive for the event depicted in a photograph, then you only know the depiction, not the actual event. I wonder what you now think of Robert Frank's images from forty years ago?

PL: In Estonia, we basically live in a society that has an imagination about many things. Robert Frank is a bit like a computer file to us, because his image language seems particularly concentrated and full of symbols, trademarks and state symbols of America, along with a healthy irony. It's easy to remember America through Robert Frank's images; they are visually quite iconic. But if we look at photographs by, say, Lee Friedlander, we find an entirely different picture of America, multi-layered and full of information, full of little images within other images. These two artists presented completely different images of America to us.

America is a well-documented country. The French and English invented photography but the Germans and Americans made it into mass media. Estonia is one of the less-documented countries, and photography still has a very low status. We have been occupied by Germans and Swedes and Russians all the time, and photographs might offer a clear picture that many Estonians are not yet willing to see.

AG: I don't know of anyone who has photographed Estonia. Do photographs of daily life in Estonia exist?

PL: We have a book called *Estonians,* which might seem similar to Robert Frank's book, but it is filled only with pictures of important writers, fine artists and politicians. What we can't see is the everyday life on the streets. We can't see anything that could be problematic.

In my research I've looked at old newspapers from Estonia, and I found that photographs were not used in the news industries until the late 1920s. Only drawings were included before then. And it shocked me. Why doesn't photography have any roots or traditions in our country? That's why we are here at the Ansel Adams Center—we have to catch up to you in this development. I think we'll manage to do it through a small group of intellectuals, journalists and art students. There is a high spirit at this point to learn everything very quickly. But what will

Alexander Alland, *Photomontage,* ca. 1943.
Courtesy Howard Greenberg Gallery. © Estate of Alexander Alland.

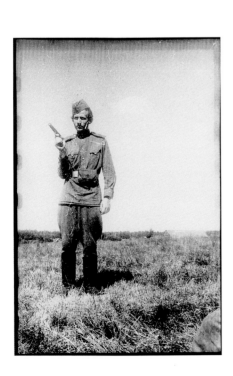

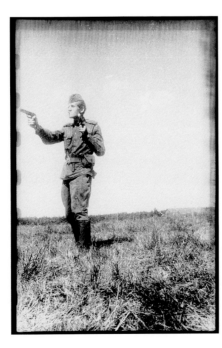

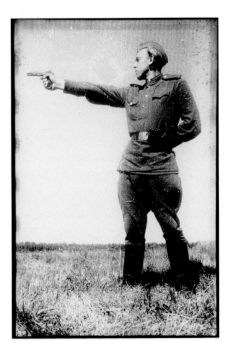

'97
'98
'99
1900
'01
'02
'03
'04
1905
'06
'07
'08
'09
1926
'27
'28
'29
1930
'31
'32
'33
'34
1936
'37
'38
'39
1940
'41
'42
'43
'44
1945
'46
'47
'48
'49
1950
'51
'52
'53
'54
1955
'56
'57
'58
'59
1960
'61
'62
'63
'64
1965
'66
'67
'68
'69
1970
'71
'72
'73

Eve Linnap, *Lisa & Johannes Soonvald,* **from the series** *The Estonian Home,* **1992-93.**

AG: Well, the culture that erased the distinction between advertising and fine art photography was in the early revolutionary years of the Soviet Union. That then carried over to the Bauhaus. I think now that one of the ways to distinguish between advertising photography and photography that could be thought of as fine art is that advertising seems to consider all syntactical relationships in the visual world as being a matter of convenience. There's a sense that advertising is the field in which the smorgasbord of photography can become just a plaything. And I think that is what worried people in the 1980s about Postmodernism, that here was a kind of fine art that said everything is fair game, that you can pick styles like picking fruit off of trees.

DK: I want to go back to history, not only how history is configured by the visual but also how people use the visual record to make history. And it seems to me there is an additional thought, which has to do with the kind of visual information you're taking back and the kind of influence it's going to have.

AG: Do your students share your skepticism about the way photographic meaning is constructed?

EVE LINNAP: They have learned that photographs are constructed, that all media messages are constructed. They don't hesitate to use their knowledge if they want to advertise their own exhibitions. They can write three articles about their own exhibition for different newspapers and they can brainwash readers very easily.

AG: When you return to Estonia and present these slides as a narrative that needs to be understood, I wonder if your students will think the presentation merely is a construction of history that the two of you have decided to create.

PL: Some will believe directly what they see, but I think that's an indication of elementary intelligence. We live in an information society, and information must be filtered.

EL: Pictures tend to be very different than life. But when we went to Western Europe for the first time, we were really shocked that some cities actually looked like they do on the postcards. We were always used to thinking of photography as one thing and reality as another.

happen if the things that happened in America or Germany are condensed? It's just importing a form again without knowing the reasons why.

AG: It sounds like detaching a style from its historical condition; then you end up with something like fashion.

PL: That has happened already in Estonia with issues like feminism, but what the art critics are doing is quoting a few sentences, and it's obvious that they like to decorate the side of image-making.

DK: You've been working very diligently at building a slide library while you're here. Have you had a chance to step back from the process of shooting and think about the kind of photography that you will be taking back? And how that

may change what you teach and write and create?

PL: We're facing a moment like you had in the late 1970s, when artists discovered that art no longer was about beauty or form and that life had changed to the extent that advertising had become a problem. My first principle was to create a good collection of classical history of photography, which will allow us, for example, to discuss a reinterpretation of Walker Evans. We also have made slides of work by what are called artists using photography, beginning with Cindy Sherman, as well as of advertising, since there is a discussion between advertising and art.

see **24**

DK: It sounds so odd to say that documentary images are so contrived, because that's the only form of truth we have. Pictures are taken to document a time or a place, yet we now say they are not accurate.

PL: They are and they are not. The camera itself is a constructing instrument. The transparency of the photograph is very similar to the transparency of the memory system, therefore photographs and memory often seem equal. I'm not saying that all photographs are fake; photographs are a way of documentation, but documentation itself is a convention. Documentary images often are about what people expect to see, or about what they remember having seen. Not every culture would agree that documentation is even necessary. History-writing is a cultural practice of Europeans and Northern Americans.

AG: And the same cultures that popularized photography also invented the archive.

PL: Actually, contemporary historical science and photography originated at the same time, during the middle of the nineteenth century. It's a strange coincidence. Perhaps photography helped promote the idea of contemporary historical science, or even invented it.

AG: So what kind of photographs would you show if you opened a museum today in Estonia?

PL: In 1986 or 1987 we started a kind of museum. We collected and exhibited a range of photographs as part of the Estonian municipal museum, but the people in higher positions decided that this collection wasn't worth their time. Now we collect all kinds of images—police photographs, anthropological photographs, amateur snapshots, photographs taken by spies in Western countries. We're more interested in non-artistic forms of photography.

AG: What would be the purpose of showing these functional photographs to people?

PL: To broaden the limits. I think the term "fine art" is confused and out of date. "Visual culture" is a more interesting term for me.

DK: Does art strengthen itself by being connected to these other areas?

PL: Yes.

EL: Some of our friends who practice fine art don't have any arts education; they have degrees in science, and they are very successful in the Estonian art world.

PL: The best artists, actually. The painters are completely out of the game.

DK: I think real creativity happens when ideas come from a variety of sources. People who are not trained in art history look at images from a different perspective.

PL: I think art historians are the most boring people in the world. For my last project, *The Top 50,* I contacted fifty of the most prominent people in the European art world, selected by a French magazine. I asked them: "Have you ever heard of Estonia?" and "Do you know anything about Estonian art." I received 17 replies, and displayed them next to portraits of the respondents. Estonian artists and critics discovered that nobody knows about them. Their self-esteem dropped a bit.

EL: It opened up a very closed situation and showed that these important Europeans didn't know anything about Estonia, and that Estonians know very little about these art world leaders.

DK: It will be exciting to see photography that comes out of Estonia after you present your findings to students and colleagues. What type of work do you think we will see from Estonian photographers in a few years?

PL: The thing about Estonia is that it doesn't have a clear trademark. The younger generation doesn't speak or think in terms of nationality, after the separation. I think much depends on very particular people, and that's really about teachers, critics and people in the institutions.

EL: Estonian art historians are in a real crisis because the new art that comes up in Estonia is not coming from Estonian art history, but from European and American traditions.

DK: Well, there may no longer be a national art anywhere in the world.

PL: The idea of a global village has been relevant for some time now. At the same time, the question of identity is also urgent. But it's rather European to divide everything into two: black and white, European and American, identity and global village. That's so limiting. ☿

Transcribed by Danielle Gold

> **The camera itself is a constructing instrument. The transparency of the photograph is very similar to the transparency of the memory system, therefore photographs and memory often seem equal.**

Peeter Linnap, *The Top 50* **(installation view), 1994.**

BREAK THEM WITH THE PRESSURE
OF PROPAGANDA OR BREAK THEM
WITH TORTURE. DON'T ALLOW
THEM TO DIE; DON'T ALLOW THEM
TO DETERIORATE TO THE POINT
WHERE IT'S NO LONGER POSSIBLE
TO QUESTION THEM.

—INTERROGATOR'S MANUAL

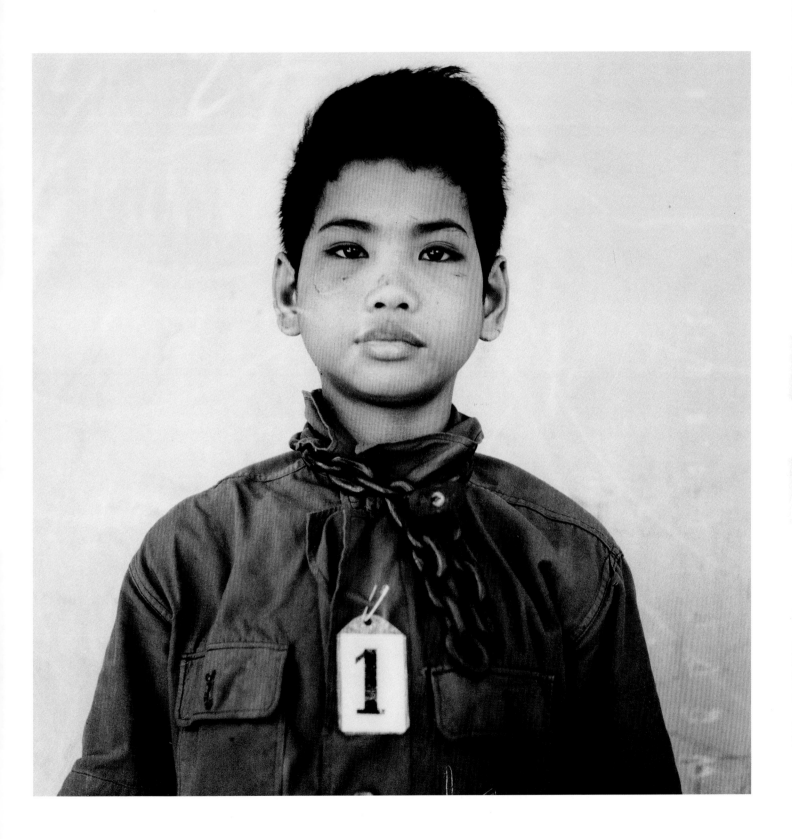

see **27**

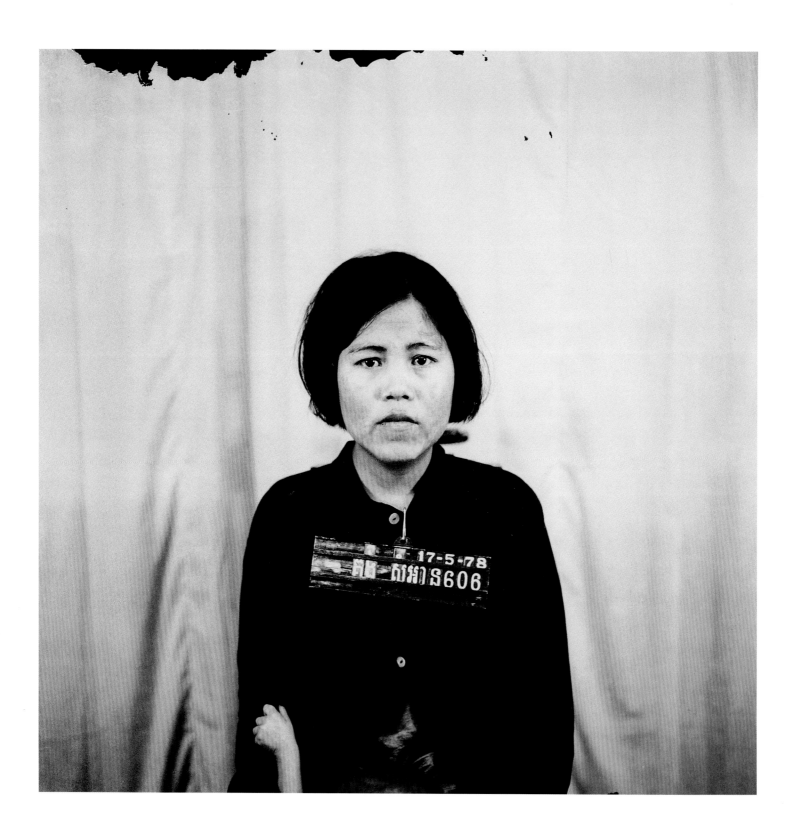

see **28**

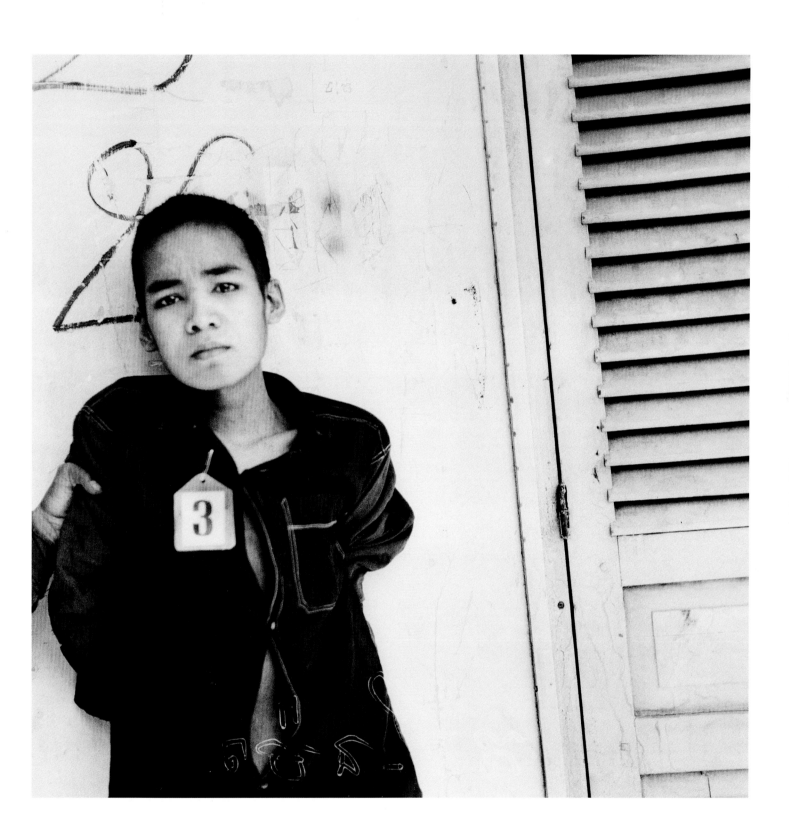

see **29**

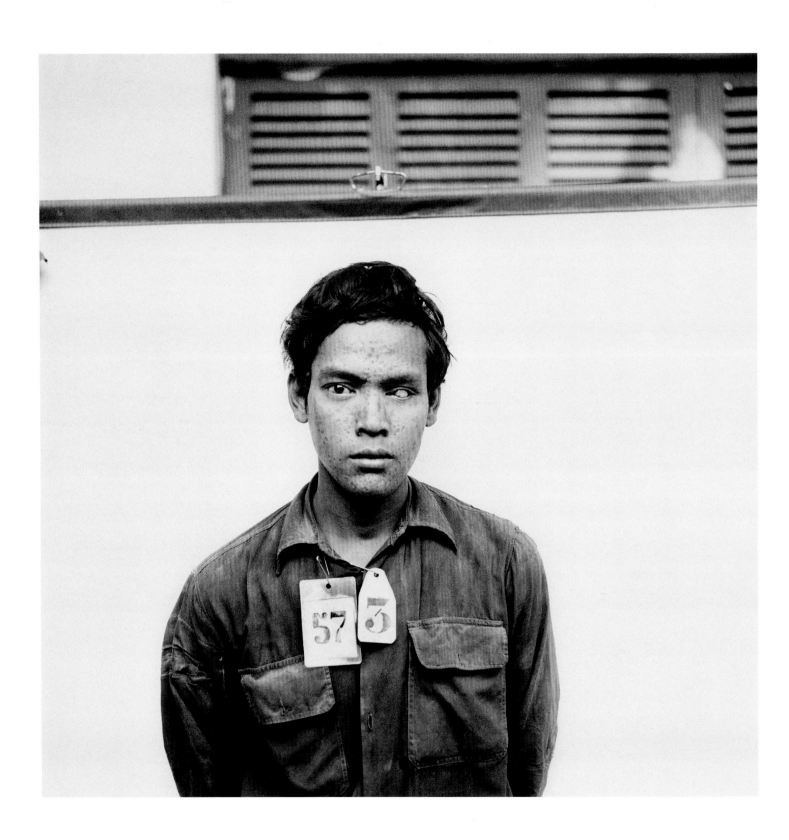

see **30**

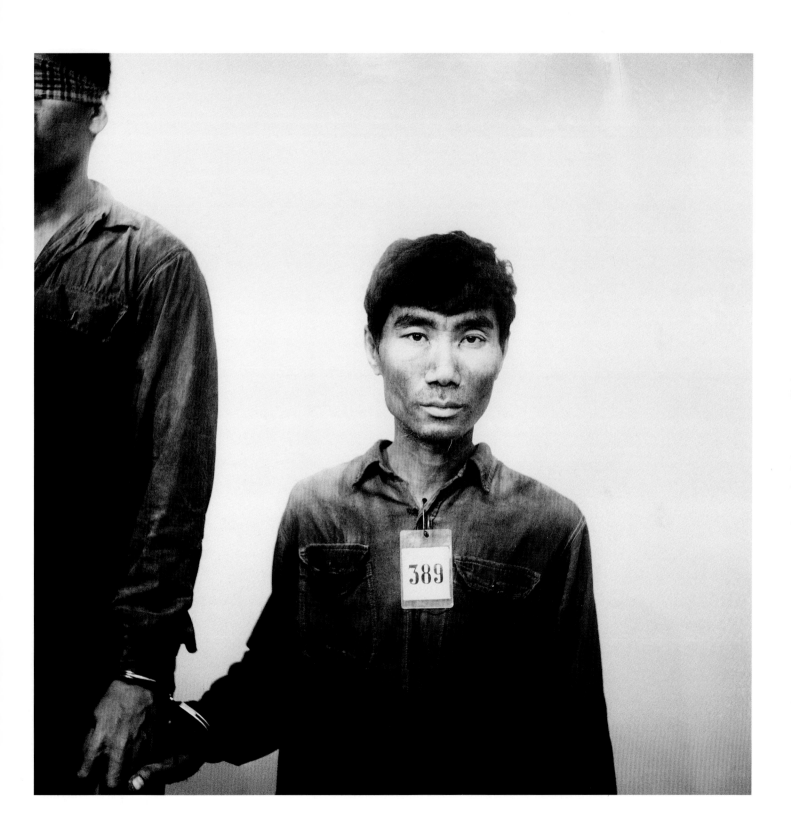

see **31**

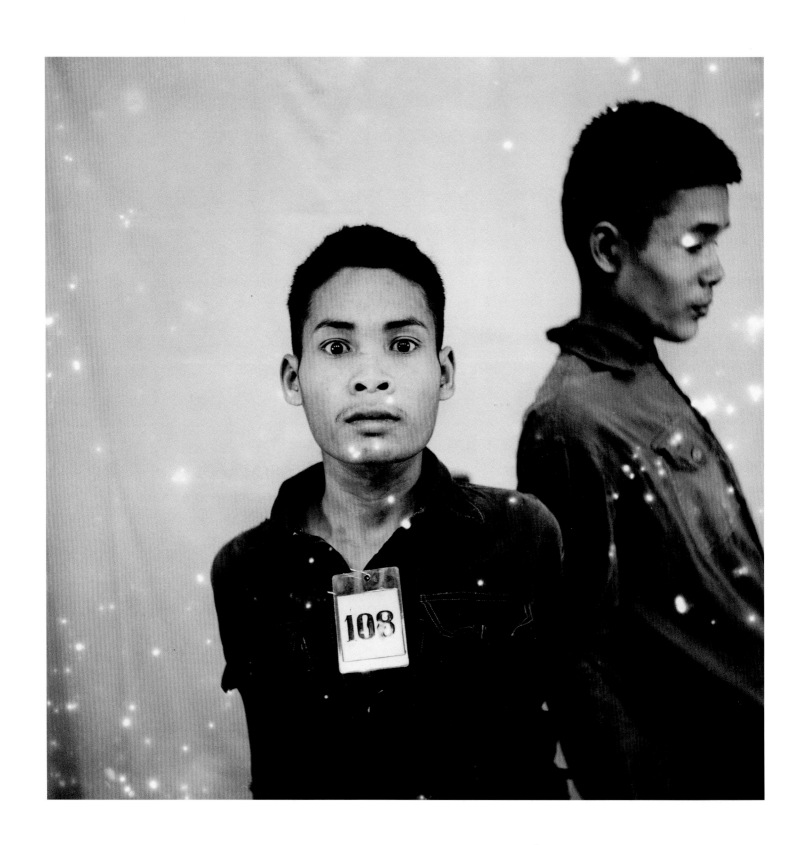

I SPOKE ABOUT THE DISCIPLINE OF THE OFFICE (S-21) AND
I TOLD HIM THAT HIS BODY, TIED UP WITH FETTERS AND
HANDCUFFS, WAS WORTH LESS THAN GARBAGE.
—INTERROGATOR

These photographs of Cambodians facing death were taken in a secret prison in Phnom Penh from the middle of 1975 through the end of 1978. During that time, the prison—formerly an elementary school—was known by its code name, S-21. Several of the prisoners in these photographs have just had their blindfolds removed. As they stare at their captors, they have no idea where they are, who is taking their picture or what will happen to them. None of them ever were released. After torture and interrogation, sometimes stretching over several months, all of these men, women and children were brutally put to death. They were the victims of a revolution gone awry.

Cambodia, under Communist rule in the mid-1970s, called itself Democratic Kampuchea and was controlled by probably the most revolutionary government in the world at that time. The country was led by a soft-spoken former schoolteacher named Saloth Sar, who used the pseudonym Pol Pot. He was Secretary General of Cambodia's Communist party, known to outsiders since pre-revolutionary times as the Red Khmer, or Khmer Rouge. Pol Pot kept himself hidden, and so did the party. People outside its ranks knew only of a shadowy, omnipotent "revolutionary organization" *(angkar pedevat)* which had "as many eyes as a pineapple." Angkar, they were told, had taken the place of their parents and had to be obeyed.

When the Communists seized power in April 1975, they swiftly evacuated all cities and towns, forcing more than two million people into the countryside to take up rural work. The new regime abolished money, markets, newspapers, private property and schools. Family life and freedom of movement were restricted. Religious practices were forbidden. Everyone was made to wear black cotton pajamas typically worn by working peasants. According to a Communist spokesman, "two thousand years of history" had ended, and a new, revolutionary era "without oppressors or oppressed" had begun.

In mid-1976, Pol Pot set in motion a Four Year Plan that was intended to modernize Cambodia, break down class divisions and lead to communism on a national scale. He proposed to triple Cambodia's agricultural output using funds earned from exports to finance industrialization, a scheme that had no relation to the country's economic, industrial or social reality. In truth, Cambodia became a gigantic prison farm; most Cambodians spent the Pol Pot era working 12 or more hours a day, with inadequate food, their every movement monitored by heavily-armed young soldiers.

In the countryside, where most of the murders occurred, victims were taken singly or in groups from prisons, homes and worksites and executed at nearby "killing fields." Those suspected of serious crimes and accused of treason were imprisoned in secrecy at S-21. Their sojourns in some cases lasted for several months, and their confessions covered hundreds of typed or handwritten pages. Prisoners were coerced to confess absurd testimonies of being employed by foreign governments to undermine the revolution.

S-21 was a top-secret facility. Its existence was known only to prisoners, prison officials and a handful of high-ranking Khmer Rouge. Because of Angkar's interest in S-21, however, its operations were fully documented. On arrival, prisoners were tagged, photographed and made to fill out autobiographical forms. According to Heng Nath, one of only seven people known to have survived incarceration, the next few days were marked by frequent, scheduled beatings. Prisoners were given little food, no exercise and little time to sleep. When interrogations began, they were exhausted, disoriented and suggestible. Many confessed to "treasonous activities" without being tortured. Others were broken by tortures so intense that in several cases prisoners died. Still others committed suicide.

As prisoners poured into S-21, an enormous archive of photographs and confessions was built up, and was made public in the years following the fall of the Khmer Rouge. In 1979, the Vietnamese army installed a sympathetic Cambodian regime in Phnom Penh and, with East German assistance, transformed S-21 into a genocide museum. Photographs, confession texts and other documents were organized into files. Places where prisoners were tortured and had slept were left undisturbed.

Thousands of photographs of prisoners and selected pages of confessions were mounted on the walls. Weapons of torture, photographs of killing fields, busts of Pol Pot carved by prisoners, abandoned clothing, fetters, chains and a survivor's paintings of torture completed the gruesome exhibition.

The archive was opened to foreign scholars in 1980. An enormous collection of images and writings were catalogued by the Photo Archive Group in 1994, after the American photographers Chris Riley and Doug Niven discovered thousands of negatives stored in a rusty file cabinet, apparently forgotten and already damaged by humidity and insects. Among much else, the S-21 archive provides awesome proof of the French politician Verniuad's 1793 statement, "Revolutions, like Saturn, devour their own."

The human cost of the Cambodian revolution was horrific. In less than four years, one million people—one Cambodian in seven—died from starvation, malnutrition and misdiagnosed or mistreated illness. Another 200,000, including everyone pictured here, were executed as enemies of the state. These are conservative estimates; the exact, probably higher number never will be known. In terms of Cambodia's total population, these losses resemble those of the Holocaust, Stalin's collectivization of the Ukraine in the 1930s, and the massacres in Rwanda in 1994.

There are some things uniquely awful and perhaps identifiably Cambodian about S-21, Pol Pot and his macabre revolution. There also are characteristics that are identifiably Communist, and drawn from China, Vietnam and the former Soviet Union. But terror is not a left-wing, Cambodian monopoly; rather, the photographs and confessions must be considered in a wider context, as dismal testimonies to inhumanity, misdirected passion, paranoid fantasies and mangled hopes. After these photographs make us frightened, nauseous and angry—as they must—they cry out for our compassion and understanding.
—David Chandler ♥

Several of the prisoners in these photographs have just had their blindfolds removed. As they stare at their captors, they have no idea where they are, who is taking their picture or what will happen to them.

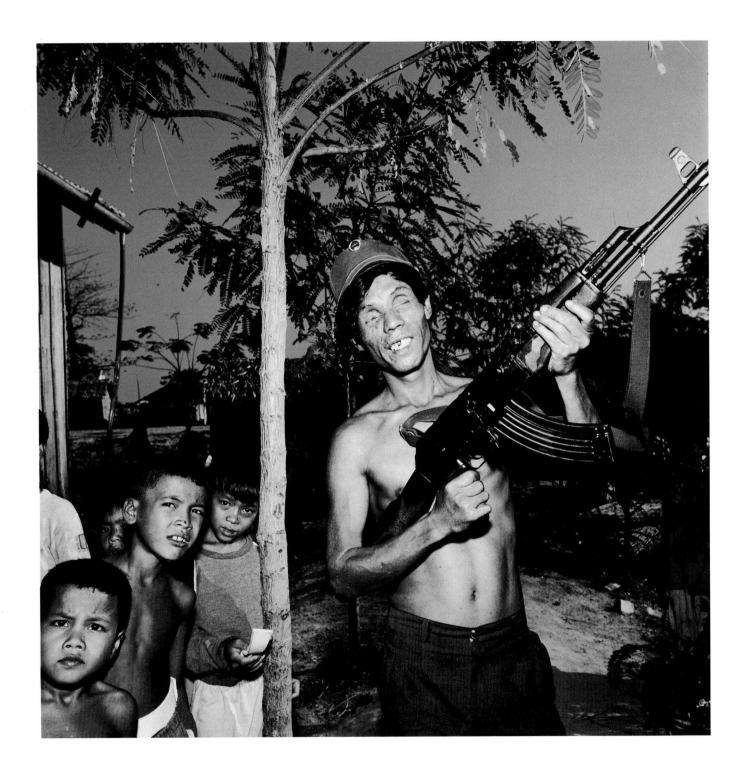

Cambodia now has the highest percentage of

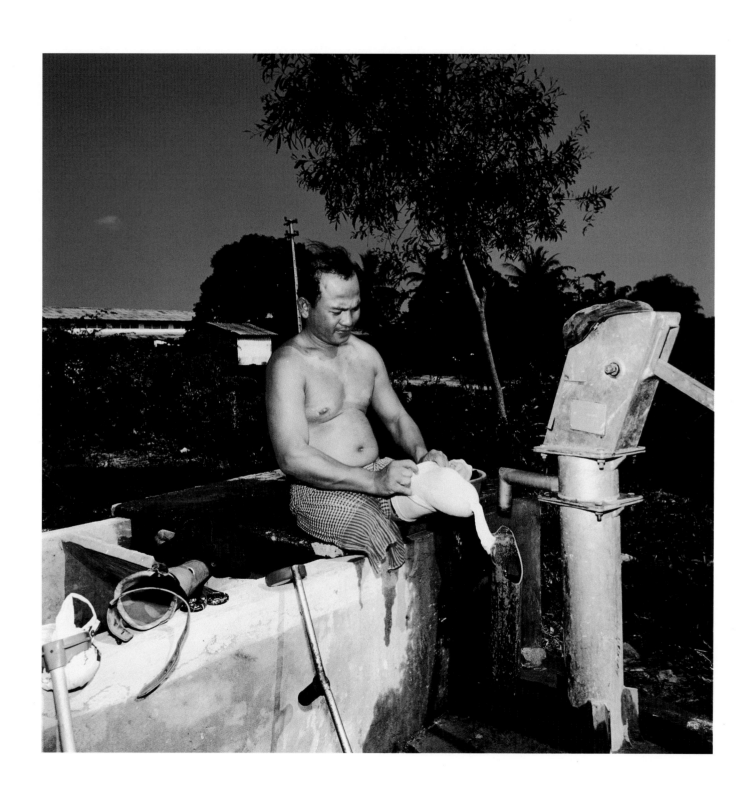

disabled inhabitants of any country in the world.

see **35**

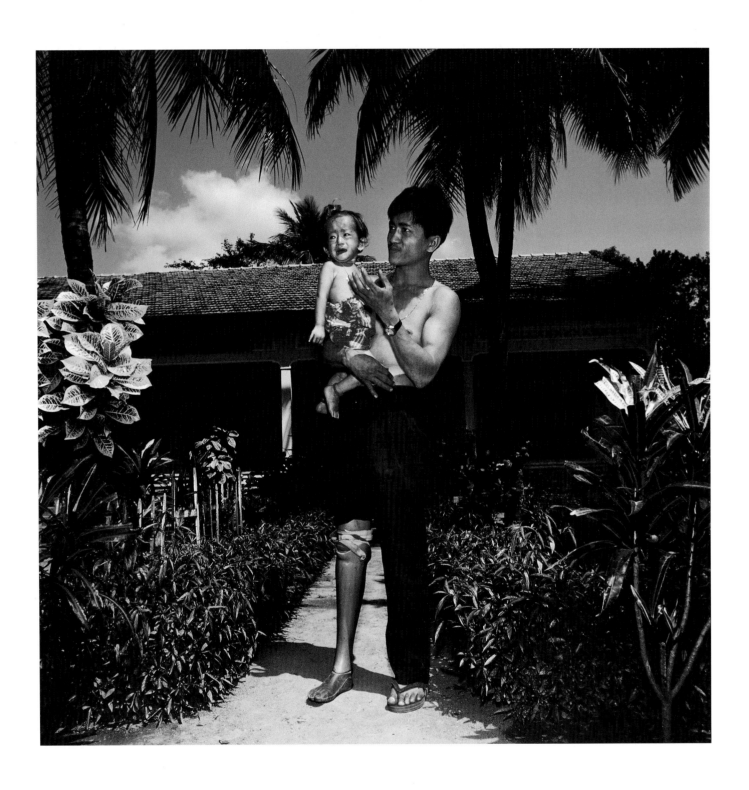

Walking through the streets of the capital, Phnom Penh, it is unusual to go for more than

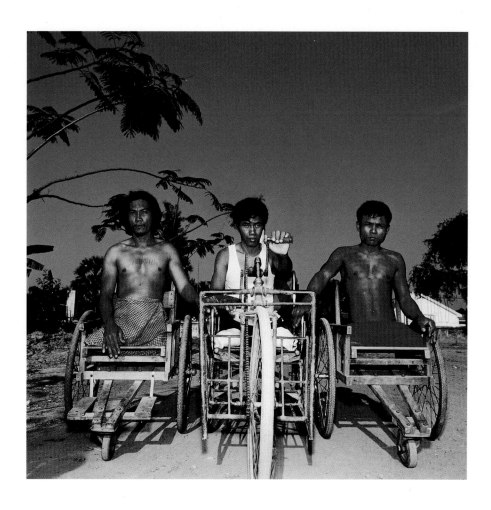

a few minutes without seeing someone missing an arm or a leg. In the refugee

villages on the Thai border, that time span is considerably shorter. It used to be that when a war ended, the enduring wounds were mostly internal. But Cambodia's dismemberment is visible and continuous, because the primary weapon in Cambodian conflicts has been the antipersonnel land mine.

The Cambodian conflict may be the first in history in which more people were killed and injured by land mines than any other weapon. Mines have been the weapon of choice for all parties involved in the war since the Vietnamese invaded in 1979, but mines also were used in Cambodia more than a decade earlier. Today, the Cambodian earth is seeded with some thirty years' worth of mines, and most of those have yet to claim their victims.

There are now more than 30,000 amputees in Cambodia (one out of every 236 Cambodians), and their ranks are growing at the rate of about 6,000 per year. At least that many die each year after stepping on mines. Some die quickly, from the blast, but most die slowly, from the combined effects of blood loss and exposure. Most of these mine victims are rural civilians. They are blown up while working in the fields, herding their livestock, fishing, gathering firewood or playing on the ground.

There are minefields upon minefields in Cambodia, a patchwork of death and destruction. Under the once-rich earth lies a material history of hostilities. In the same area one might find: an OZM-3 mine made in the USSR from the early years of the Vietnam War, put there by North Vietnamese soldiers to protect their base camps along the eastern border; a grouping of Chinese-made mines around a tree, placed there by the Khmer Rouge to trap Lon Nol troops in the early 1970s; and M16A1 mines made in the U.S.A., put out recently by one of the resistance groups retreating from the Phnom Penh government army. When one of these mines explodes under a farmer's footfall, it is impossible to say who is responsible. Mines operate outside the rules of war. They make their own rules.—David Levi Strauss ♀

THERE IS NOWHERE WITHOUT MINES. THERE
ARE MINES FROM HERE TO THE HILLS.
THE LAND HAS BECOME NARROW.
—AN INDEPENDENT CAMBODIAN MINE-CLEARER

Hugh of Lucca (1251), 1937.

Facing page: *Etienne Gormelen (Paris plague of 1581),* 1934.

see **39**

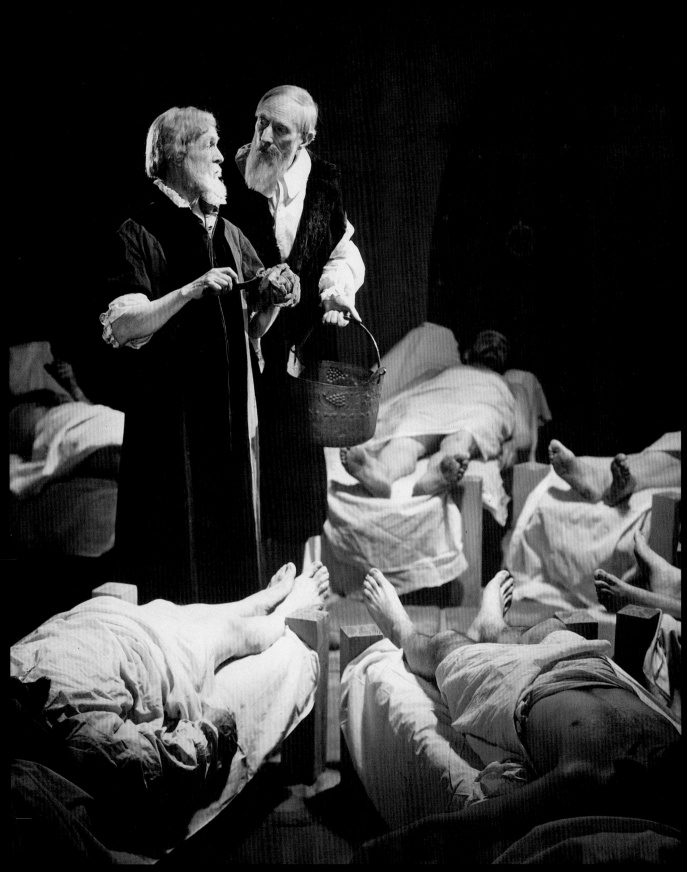

see **40**

Thomas Gale (1507–1586), 1940.

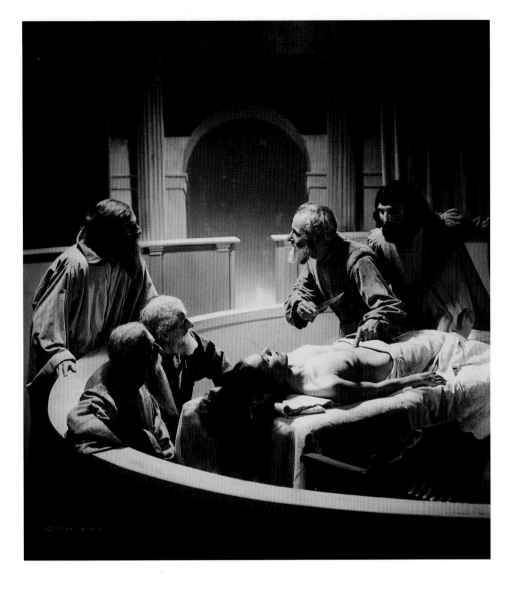

Hieronymous Fabricus Ab Aquapendente (1537-1619), 1948.

Below: Maquette for *Hieronymous Fabricus Ab Aquapendente (1537-1619)*.

FROM 1927 TO 1950, LEJAREN À HILLER produced 200 advertising photographs for Davis and Geck, a surgical supply manufacturer, purporting to illustrate the "History of Surgery." Based on the company's historical research and the photographer's own study of period costume and detail, Hiller's elaborate tableaux proved so breathtaking that a portfolio of seventy such images was published in 1944 as *Surgery Through the Ages: A Pictorial Chronical*.

Trained as a magazine illustrator, Hiller proved to be an ideal ad man, helping to create a unique hyper-realist style in the service of consumer goods. Yet consumer desire is not all that Hiller arouses. His photographs, while painstakingly prepared and previsualized, produce the symptoms of a fun-house mirror, inducing the same kind of queasiness that many feel when they experience the sight of fresh blood.

History, meanwhile, seems anesthetized to the invasive procedures of the photographer's imagination, which included a propensity for having female victims lose their clothing in the process of dying or being restored to health. Of course history has no grounds for a malpractice suit, since the majority of the subjects Hiller undertook date from well before photography's public appearance in 1839. To compensate for this absence, he relied on his talents in drawing and set design, conceptualizing scenes of kitschy drama that, when photographed, uncannily partake of both accuracy and anachronism.

Little else is known about Hiller that would explain his motives and intentions, other than that his career lapsed into obscurity and his original prints were consigned to oblivion until rescued from the trash. What is known to remain of his work is in the collection of the Visual Studies Workshop in Rochester, N.Y.

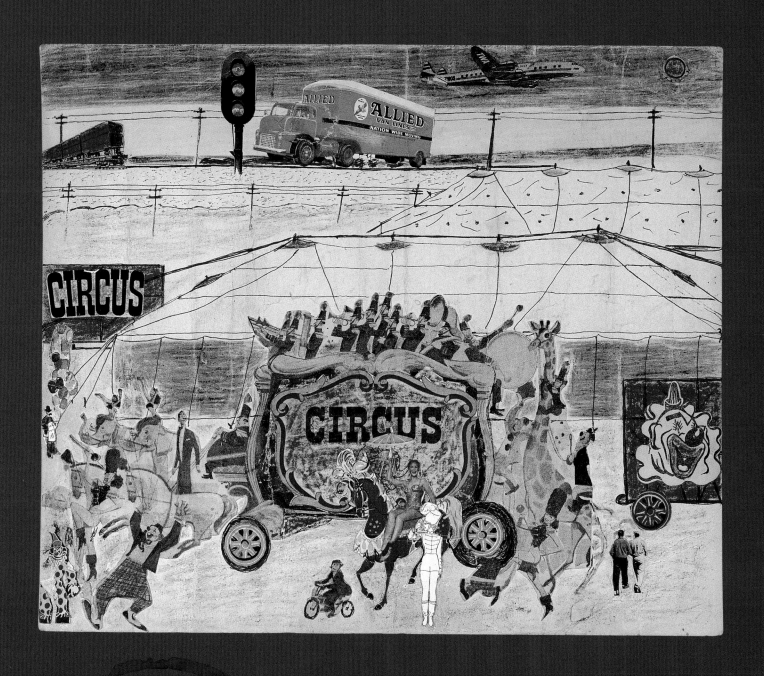

C.T.
McCLUSKY

see 42

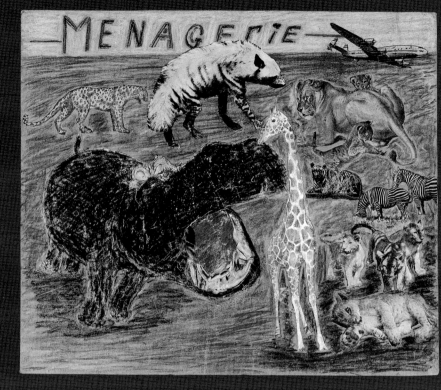

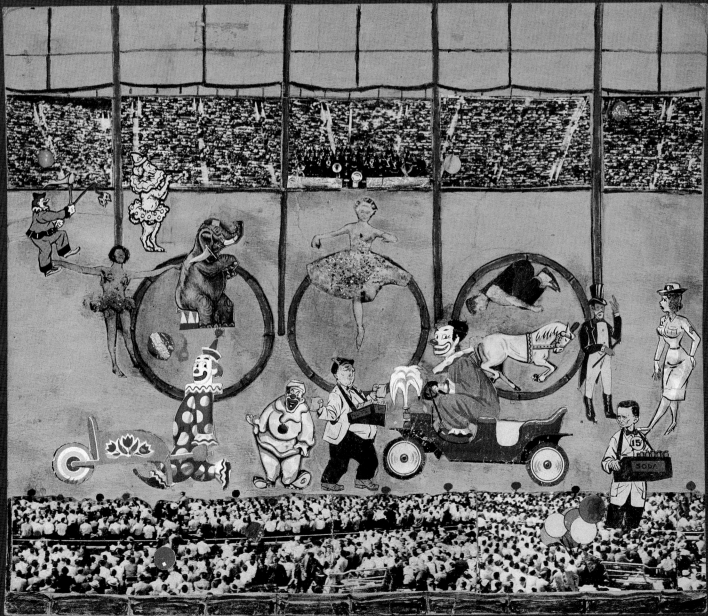

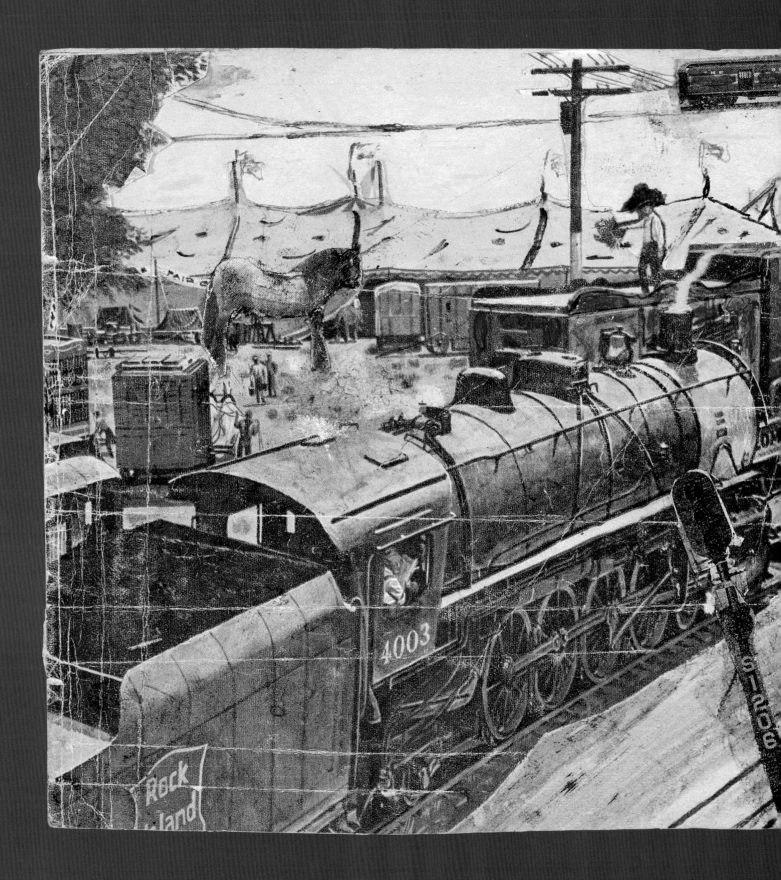

see **44**

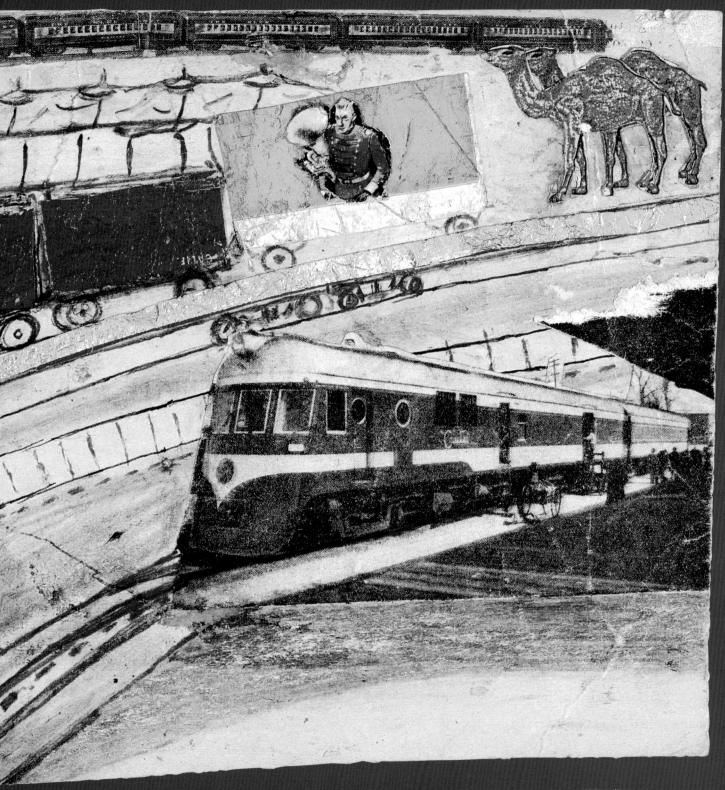

TRUNK SHOW

Little is known about C.T. McClusky other than that he worked as a circus clown (most likely during the late 1940s and early '50s), resided in a rooming house in Oakland, California during the winter months and made wonderful paper-on-cardboard collages that depicted daily life in the circus environment. I happened upon his work nearly twenty years ago while sorting through a table of tools, postcards and Mexican ceramics at a swap meet in Alameda, California. Inside a battered black suitcase with a torn circus advertisement fixed to one side, I found—along with paper scraps and fishing weights—53 collages constructed from magazine cutouts, candy wrappers and animal cracker boxes. I inquired about the origin of these unusual pieces, and the woman tending the stand shared with me her memories of the artist: "When I was a little girl, Mr. McClusky lived at my mother's rooming house. He used to tell me stories about working as a clown and traveling the country with the circus. I liked him, but he drank a lot. I remember he had a big stack of old *Life* magazines under his bed, along with this suitcase. Once in a while I would see him making these pictures. When Mr. McClusky died, Mom cleaned out his room and gave them to me." Fascinated by these works and this brief story of their creator, I purchased the collection, realizing that McClusky's collages were an important addition to the field of self-taught art.

Rich in color, movement and detail, the works are narrative in nature and can be categorized by theme: Big Top set-ups, transportation, animals, scenics, circus folk and the three-ring show. The railroad tracks and highways that extend throughout the collages suggest the endless roads that brought the circus from town to town and a sense of constant transition and rootlessness. Stylistically, in their experimentation with incongruities of scale, McClusky's works are reminiscent of Dadaist collages from the 1920s, and his incorporation of photographs recalls the work of collage pioneers such as John Heartfield and Jess. What distinguishes McClusky is his unique, deeply personal reconstruction of the circus milieu as a phenomenon of American entertainment and lifestyle, and his untrained yet remarkably assured skill for piecing together images and imaginings of our Big Top fantasies.—John Turner

BIG SAVINGS! TV GUIDE'S JUMBO VALUE SUBSCRIPTION OFFER

A POEM BY TOBEY KAPLAN

A photograph of cowboy rodeo stars, a back shot
of silhouette, smoky halos light their arms stretched out
raising their big hats to the audience
the horses' buttocks muscled, controlled by
the men's legs wrapped in leather

I look again, it's a shot of ballerinas
on toe, frozen prior to pirouette
or after, their hands draped swan-like at their sides
eyes held into their heads, a balance
in grace, muscled legs and tight shoulders,
an offering of bodies to dance and its stillness

Clearly the first glance of rodeo
the second of ballet, both performance, stagelights
skilled coordination of those who seek praise
that practice masks ordeal of blood through veins
for this fortune of moment under lights
an available glory respect from strangers

The images converge in my mind
trails rise together into the world
of physical blunders and discovery
where my mistake is accomplishment
through glare of lights, outlines and forms possible
what men and women dream to attain
sweat suddenly permanent dignity
what brings me so near to bodies and skeletons
I do not know, a lump in my throat
about properties illuminated in the mind
blossoms pinned to ballet skirts
horse manure and straw beyond the stage
the glasses they fill with beer or champagne
darkness that trembles.

My grandma always said,
"You criticize, because when
point one finger at someone,
three other fingers are pointing
right back at you."

"Be Careful when

you

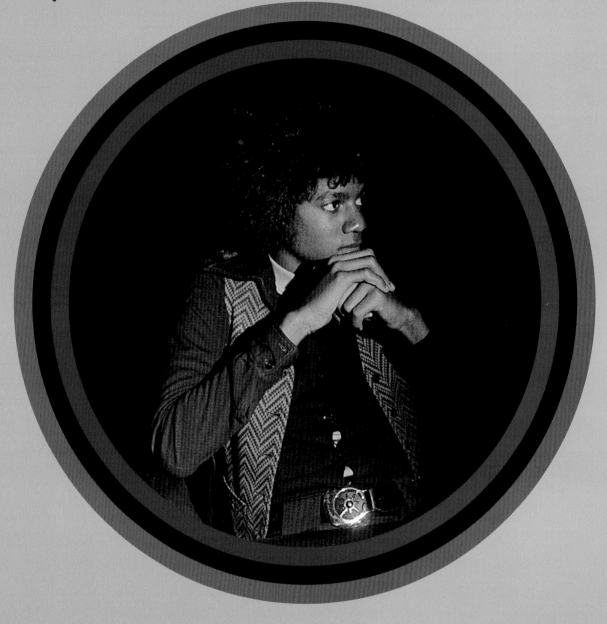

Recently I dug out some photographs of Michael Jackson I had taken many years ago. I hardly recognized him. Every physical trace of Africa has been purged from his body. I no longer can claim him as family -- not even a distant cousin.

IF I COMPARE MY face to the one staring back at me from my own twenty-year-old snapshots, I see that while my face is now rounder and a bit more serious, my nose is still the same shape and my skin the same color. But there is an eerie, disturbing schism between my personal memory of Michael Jackson, the ambitious and talented young performer, and his current mediated image as the King of Pop. Are these old photographs (*of Jackson? of myself?*) a complete fiction? A play on reality? A mirage?

I FEEL comfortable calling Ella Fitzgerald, Jimi Hendrix, Langston Hughes or Toni Morrison FAMILY. We could be third, fourth or twenty-fifth cousins. Ten years ago I could have referred to Michael as my brother or cousin. *This is no longer true.*

I REMEMBER the very first time I photographed him. The year was 1972, I was fresh out of high school and barely surviving as a freelance photographer. One night I was assigned to cover a music awards show for which the 14-year-old Jackson was a co-presenter with Donny Osmond. At the time, the popular press portrayed the two as tinted mirror images of each other. Donny/*Michael*. The Osmonds/*The Jackson Five*. WHITE/BLACK.

TWO child television actors accompanied the two music celebrities, one black, one white. Jackson and his brown counterpart both wore tuxedos, seemingly appropriate dress for the occasion, while Donny and his younger surrogate were dressed casually in jeans and shirts printed with decorative designs. *A coincidence?* I think back to the many times I've seen black people overdress for an occasion to show a hostile and suspicious society that it is wrong about us: we do know the proper cultural queues and rituals after all. In their formal dress, Jackson and his co-presenter seemed intent on making a social statement: they had arrived. Osmond and his young friend did not need to make this pronouncement. They had always been there.

"THEY'RE JUST waiting for us to do something wrong and mess up, but we'll show them," Jackson would say. What he wanted to show everyone, of course, was proof that he was the best. Thus, his rehearsals were longer, and nothing short of perfection was tolerated. Black parents often told their children we had to work twice as hard to get half as far. Simple math tells us we would have to work four times as hard for parity. Since Jackson was driven to be bigger than Elvis or The Beatles, he would push himself eight times harder than anyone else to reach his goal.

At that time my parents, like many other black parents, often told their children they had to work twice as hard to get half as far.

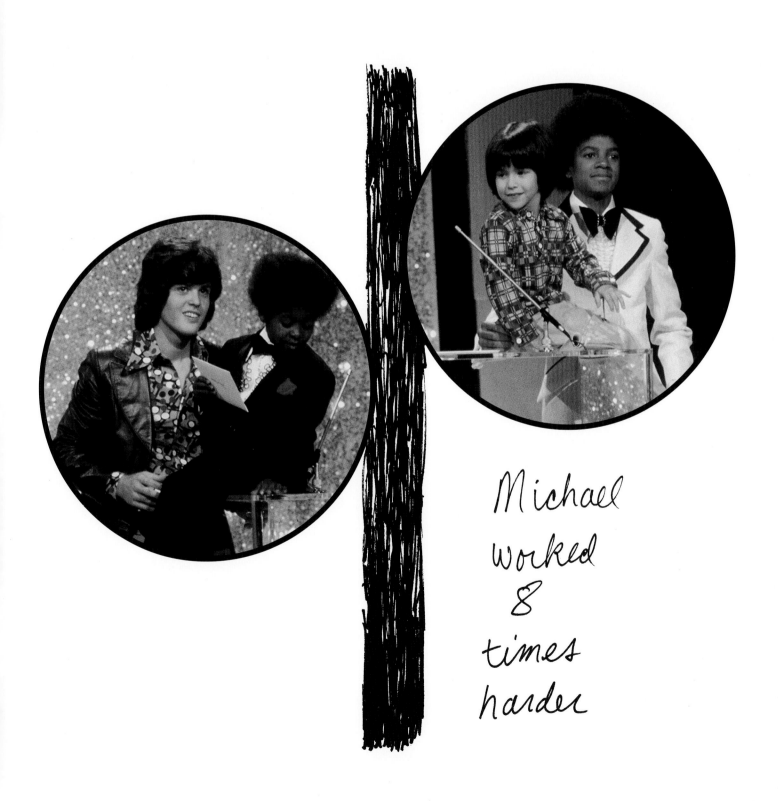

Michael worked 8 times harder

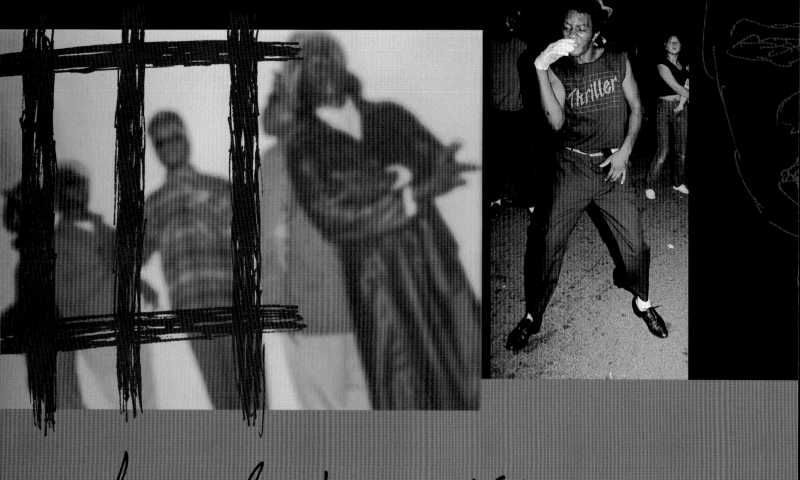

In order for whiteness
to be a sign of purity
and goodness, blackness
must be located as ~~the~~ the
site of impurity and baseness—
black people have fulfilled
their function as ~~a~~ a screen
onto which <u>ALL</u> negativity
is projected.

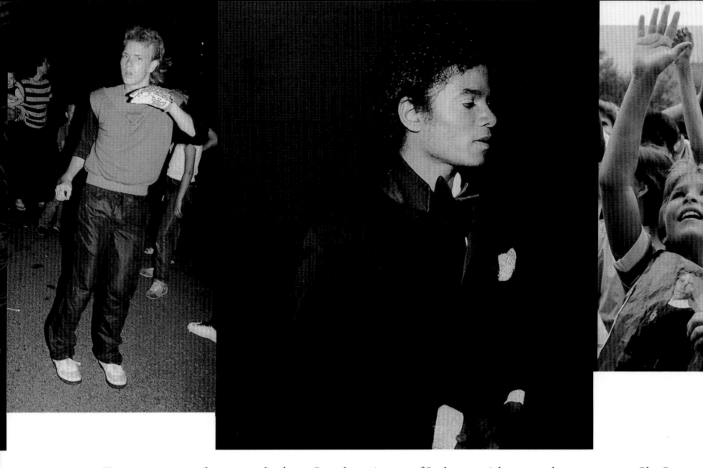

DURING another awards show I took a picture of Jackson with two other pop stars, Sly Stone and Rick James. This image speaks volumes about the line of demarcation between "good" Negroes like Jackson and "bad" ones like Sly Stone and Rick James, with their police records and well-documented histories of drug abuse. The perception that black people have a propensity for sociopathic behavior has been prevalent in this culture for centuries. Dark people with dark natures are very common in American literature, as Nobel Laureate Toni Morrison demonstrated in her 1993 collection of essays, *Playing in the Dark*. Morrison suggests this view is so widespread that many black people have internalized it, perhaps fearing that their dark nature will reveal itself if not properly monitored. Jackson was determined to be different. He took every precaution to make sure that his media image was no more threatening than Peter Pan's. It became my job as his personal photographer to emphasize Jackson's boyish innocence and his soft, non-aggressive nature.

UNFORTUNATELY we were not aware at the time of the polarized role that black people fulfill in the collective psyche of America. In order for there to be saints there also must be sinners. As Hegel implied in his *Master/Slave Dialectic*, for centuries black people have fulfilled their function as a screen onto which negativity is projected. Cultural critic Frantz Fanon, in *Wretched of The Earth*, referred to this notion as mental colonialism. As he wrote, "*...the total result looked for by colonial domination was indeed to convince the natives that colonialism came to lighten their darkness. The effect consciously sought by colonialism was to drive into the natives' heads the idea that if the settlers were to leave, they would at once fall back into barbarism, degradation, and bestiality.*"

AS I LOOK at my other photographs of Michael Jackson, I watch as his hair changes from tight curls to long flowing tresses. His nose changes shape and his skin color gradually transforms as he gazes through the cracked and distorted mirror of a society drunk with its own image, the image of white superiority. I think to myself, *yes indeed, his racial self-hatred is becoming apparent.* And this act of looking makes me become aware of my own racial self-hatred. I too have consciously changed my speech, my hairstyle and my personal history. A symptom, no doubt, of an unconscious inferiority complex.

WHEN I THINK back to my childhood and the magazines I'd flip through to gaze at pictures of beautiful women, it occurs to me that all of the primary objects of my adolescent desire were white: Ginger and Mary Ann in *Gilligan's Island*, Ellie May in *The Beverly Hillbillies*, and Pussy Galore in *Goldfinger*. It was no wonder I did not readily recognize other kinds of beauty. If I did not recognize as beautiful the same features black women share with myself, what did that say about my own sense of self?

WHICH TAKES me back to Michael Jackson. His phenomenal international rise to celebrity may be explained not only by his incredible genius as a performer but also by his ability to fulfill cross-cultural definitions of *hero* in the classic sense. Prior to the alleged molestation scandal of 1993, Jackson was perceived as a poetic Golden Child, a product of nature, divine, androgynous, virgin. Animals and children flocked to his side. He has seamlessly metamorphosed from black to white, a transformation signified by his hairstyle changing from tight curls to long flowing tresses. Apparently absent in Jackson are the "destructive" carnal desires of most people; he is a vegetarian who neither smokes nor drinks. And out of his mouth comes song, the musical utterances of the poet.

THE MESSAGE society is sending to us by way of its lionization of Michael Jackson is that we should aspire to be white, wealthy, mild-mannered and soft-spoken. We should send our sexual desire into exile, maintain a childlike innocence and not question authority. Over his twenty year career, Jackson has transformed himself from an entertainer admired for his talent into a perfect Puritan poster boy, one who has pulled himself up by his bootstraps and quite literally melted in the pot and been recast in the classic American mythical image. I believe that Michael Jackson functions as an identifiable icon of the American psyche and a reflection of its racial unconscious. His image is the screen onto which we project our dreams, aspirations, anxieties and fears.

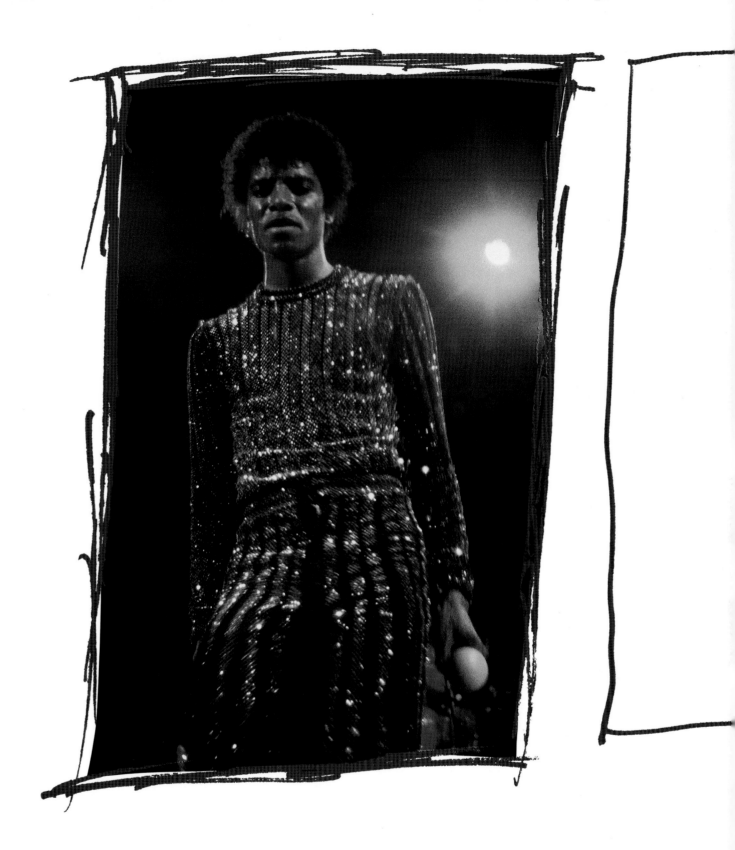

This act of looking also makes me aware
of my own self loathing, as I think of
the choices I've made to distance myself
from African American culture in order to
be more acceptable to white culture and
participate in the American Dream.

250 Fourth Street, San Francisco CA 94103
415.495.7242 Fax 415.495.8517 E-Mail FOPbooks@aol.com

The Friends of Photography Bookstore is an invaluable resource for photography-inclined bibliophiles wh would like the finest new photography titles delivered straight to their doors. Following is a choice selec tion of new books for Spring 1996. Please use the form on the facing page to place your order.

Mine Fields. Photographs and text by Bill Burke. Nexus Press, 1995. 120 pages, 180 duotone and color reproductions. $50 cloth-bound, **special price $45.** Bill Burke's photographic psychodrama, set in Cambodia, reveals the snares and pitfalls encountered when an artist probes the limits of fascination. Burke's third Nexus Press volume picks up where the groundbreaking *I Want To Take Picture* left off, taking readers deeper into Cambodia and the artist's idiosyncratic aesthetics. Images and text merge in an unusual journal format, lending an aura of surreality to Burke's personal interpretation of a haunted country.

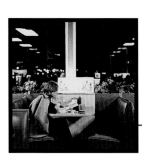

A Sense of Common Ground. Photographs by Fazal Sheikh. Scalo Publishers, 1996. 96 pages, 130 duotones. $45 clothbound, **special price $40.50.** Fazal Sheikh's photographs challenge commonly accepted views of refugees from Sudan, Ethiopia and Somalia as purveyed by international photojournalists who spend perhaps one day getting "the story." By contrast, Sheikh spends weeks in each location he shoots. This beautiful book, with its gentle, unmanipulated black-and-white images, offers a refreshing antidote to clichéd images of mute victims and diverse cultures, and demonstrates why this young photographer already has received numerous awards for his documentary work.

What We Bought: The New World. Scenes from the Denver Metropolitan Area 1970-1974. Photographs by Robert Adams. Sprengel Museum, Hannover, 1995. 202 pages, 180 duotones. $40 clothbound, **special price $36.50.** *What We Bought* is a well-crafted book that reproduces for the first time a powerful body of Robert Adams' earlier work from the Denver area in the early 1970s. As always, Adams challenges assumptions about progress and resources in the modern world.

Exils (Exiles). Photographs by Josef Koudelka. Photo Copies, Centre National de la Photographie, Paris, 1988. 150 pages, 61 duotones. In French. $65 clothbound, **special price $58.50.** Josef Koudelka's exquisite black-and-white documentary photographs of Eastern Europe were groundbreaking when first published in the 1970s. With the American edition long out of print, this French edition of Koudelka's classic book is a must-have for every photography library.

Dressed for the Photographer: Ordinary Americans & Fashion, 1840-1900. By Joan Severa. Kent State University Press, 1995. 592 pages, 272 black-and-white illustrations. $60 clothbound, **special price $54.** In this thoroughly researched work, Joan Severa addresses the availability of current fashion to people of modest means in nineteenth-century America while drawing on a fascinating collection of early photographic imagery to illustrate her ideas. This is an essential book for anyone interested in history, fashion or photography.

The Photographs of Dorothea Lange. Edited with text by Keith F. Davis. Contributions by Kelle A. Botkin. Hallmark/Abrams, 1996. 132 pages, 83 tritones. $35 clothbound, **special price $31.50.** Dorothea Lange is widely recognized as one of the most eloquent and influential photographers in American history. Reproduced here are important works from every phase of her career, from vintage prints of classic images to those that are far less familiar.

Disfarmer. Twin Palms Publishers, 1996. 212 pages, 200 four-color plates. $50 clothbound, **special price $45.** In Heber Springs, Arkansas, a reclusive photographer known simply as Disfarmer created an uncanny record of American rural life during the 1930s and '40s. Working out of his modest studio, Disfarmer created portraits of townspeople that are direct and unpretentious. These photographs, many unpublished or rarely seen, underscore his uniquely American vision of place. Due April.

Treadwell. Photographs by Andrea Modica. Essays by E. Annie Proulx and Maria Morris Hambourg. Chronicle Books, 1996. 88 pages, 40 duotones. $40 clothbound, **special price $36.** Andrea Modica is one of the most accomplished and critically acclaimed young photographers to emerge in the last five years. *Treadwell* is Modica's first major published collection, a rich, empathetic and often wrenching study of small-town family life in upstate New York.

Friends of Photography Bookstore
Order Form

250 Fourth Street, San Francisco, CA 94103
415.495.7242 Fax 415.495.8517 e-mail: FOPbooks@aol.com

Quantity		(Regular Price)	Special Price	Amount
___	*Mine Fields*	($50.00 cloth)	$45.00	_____
	A Sense of Common Ground	($35.00 cloth)	$31.50	
___	*What We Bought: The New World*	($35.00 cloth)	$31.50	_____
___	*Exils (Exiles)*	($65.00 cloth)	$58.50	_____
___	*Dressed for the Photographer*	($60.00 cloth)	$54.00	_____
___	*The Photographs of Dorothea Lange*	($35.00 cloth)	$31.50	_____
___	*Disfarmer*	($50.00 cloth)	$45.00	_____
___	*Treadwell*	($40.00 cloth)	$36.00	_____

In Calif. please add applicable sales tax (8.5%). Shipping and handling charges: Continental U.S., per destination: via UPS, allow 1-3 weeks for delivery. $6 for first book, $1 for each additional title. Foreign, per destination: via surface mail, allow 6-12 weeks for delivery. $10 for first book, $2 each additional title.

Subtotal	_____
Sales Tax	_____
Shipping	_____
Total	_____

Ship to: _____

Street Address _____

City _____ State _____ Zip _____

Telephone _____ Subscriber/Member # _____

Payment: My check is enclosed *(U.S. funds, foreign remittance by International Postal Money Order only)*

Please charge to my credit card ☐ VISA ☐ Mastercard ☐ AmEx

Name as appears on card _____

Card number _____ Exp.Date _____

Signature _____

Please fold along this line and tape closed.

2:1

Stamp!

The Friends of Photography
250 Fourth Street
San Francisco, CA 94103-3117

Stamp!

Please fold along this line and tape closed.

2:1

Benefits of Membership in
The Friends of Photography

Basic Benefits of membership:

→ A one-year subscription to see
→ Free admission for member and a guest to the Ansel Adams Center for Photography in San Francisco
→ A subscription to re:view, The Friends of Photography members' newsletter
→ Discounts on all purchases from The Friends of Photography Bookstore
→ Participation in the Connections Network (free admission to five photography museums and discounts at three others throughout the U.S.)
→ Priority registration for The Friends' seminars and classes

Membership levels
$2,500 Benefactor
All basic benefits plus:
→ The Benefactor print by Helen Levitt, plus your choice of three photographs from The Friends' Collector Print Program

$1,200 Patron
All basic benefits plus:
→ The Patron print by Nan Goldin, plus your choice of three photographs from The Friends' Collector Print Program

$500 Contributing Membership
All basic benefits plus:
→ Your choice of two photographs from The Friends' Collector Print Program

$300 Sustaining Membership
All basic benefits plus:
→ Your choice of one photograph from The Friends' Collector Print Program

$125 Supporting Membership
All basic benefits plus:
→ Participation in the annual Members' Portfolio Review
→ One see logo t-shirt

$80 International Membership
All basic benefits for those living outside the United States.

$75 Family Membership
All basic benefits plus:
→ Free admission for the *entire* family to Ansel Adams Center for Photography exhibitions

$60 Associate Membership
All basic benefits of membership

Special Categories
$90 Institutional Subscription
For universities, libraries or other institutions. One-year subscription to see only (no other basic benefits)

$48 Subscriber
One-year subscription to see only (no other basic benefits)

For faster service, contact us directly
Phone: 415.495.7000
Fax: 415.495.8517
E-Mail: seefop@aol.com

Feast my eyes!

Start my one year membership in The Friends of Photography immediately, so that I'll get see and enjoy all the benefits of membership described at left.

For faster service, contact us directly.
Phone: **415.495.7000**
Fax: **415.495.8517**
E-Mail: **seefop@aol.com**

Please choose membership level (includes subscription to see):

___ $60 Associate ___ $125 Supporting ___ $1,200 Patron
___ $75 Family ___ $300 Sustaining ___ $2,500 Benefactor
___ $80 International ___ $500 Contributing

Subscription catagories:
___ $48 Subscriber
___ $90 Institutional

☐ My check is enclosed (U.S. funds, foreign remittance by International Postal Money Order only)

☐ Please charge to my credit card ☐ VISA ☐ Mastercard ☐ AmEx

Name on card _____ Exp. Date _____

Card number _____

Signature _____

☐ Please bill me.

☐ Please send me more information about The Friends' Collector Print Program.

Name(s) _____

Street Address _____

City _____ State _____ Zip _____

Phone _____ E-mail _____

Flowers for Robert Mapplethorpe

I.

POEM BY JOHN WOOD

Near the Pantheon
a boy whose shoulder shows
the purple of desire,
whose muscled chest
is brown as dying callas,
offers the tourists flowers
and expensive chestnuts
out of season.

His jeans are as tight
as the unblossomed peonies
I think of buying. I ask him
how long before they open.
"Tomorrow," he lies. Still
I take bundles back
and chestnuts, too. Tonight
he and his leathered
bullyboy will think of me
when they buy wine and Vaseline,
will think I am waiting
tomorrow's hard buds to open
as I sleep, will think
I'll awaken in a kind of tourist's rage
with what the night has made.

2.

There are always flowers left
on the grave of John Keats.
Neat schoolboys in blazers
leave the roses they bought
on the Spanish Steps. And they
go home to England intending
to think, henceforth,
on beauty alone, and always
tell the truth. Thick ladies
in suits come to lay violets
there. They hand new cameras
to strangers who blur them
but save for a fall's coming class
some proof of love, some sketching
of why their eyes glaze so
when they speak of him, glaze
like sex or preaching,
to prove a love
they've forced for years indifferent teens
to learn like prayers.
 Some will recall
an urn, a bird, a silent peak,
a blurred, bending figure placing violets
once when they were young, their skin
quick as matches, when they hated
school and Keats and anything that held
the eyes, the tongue, the hands
from love's circuit, those gaudy explorations
older, richer than the oldest poems.

3.

Wheat and poppies bloom
along the Appian Way.
Bees have built
into the broken walls,
and honey slips down
the bricks.
A motorcycle passes.
The sound is mean as bees,
angry as a hundred hives.
The boy in rear holds
the hips of his friend
tightly, and they both are
laughing as if the comb of the world
was dense, was full, was theirs.

4.

Crossing the Ponte San'Angelo,
I see a page ripped from a magazine.
A penis is poised for entry
from behind. A long-haired girl
looks over her shoulder and speaks.
In a balloon over her head the words
are written out. She says, "Stick it in."
Bernini's statues look down.
Hadrian's tomb rises in front.
A man carrying roses and bread
passes me, also notices the page.
"There's nothing you'd want there,"
he says. He is younger than I,
looks neither prude nor lunatic,
but is wrong. Had I enough Italian,
I'd tell him no, that I want
the mean words of their rough love,
that I would take them and make silent
as the rise of bread their copulation,
that I would press them like roses
or fold them like a friend's handkerchief
stiffened with the crust of need.

Coda

The bruised boy found leather
for his labor, and the bikers
alone where poppies bloom
saw honey break from a wall.

But those leaden virgins in love with Keats,
the boy bringing home bread and roses
only found ritual at the petals' lips—and shadows,
the shades of lusts embraced in sleep alone.

Image selection menu from the CD-ROM *Robert Mapplethorpe: An Overview*.

THIRD
PERSON
SINGULAR
Profiles and personae

Repackaging Mapplethorpe

By Michael Read

I just hope I can live long enough to see the fame.
—Robert Mapplethorpe

It often has been suggested that in the 1980s, artists replaced rock stars as the focal points of popular culture. This premise is particularly apt when one considers the ongoing commercial viability of Robert Mapplethorpe. In thinking about Mapplethorpe's carefully crafted superstar status in the art world, I am reminded of the

famous *Rolling Stone* cover from the early 1980s, which chronicled the comeback of The Doors. Celebrating a marketing coup fueled by the fact that the band's singer, Jim Morrison, had slipped from this world with a whimper a full decade earlier, the magazine's cover trumpeted: "He's hot. He's sexy. He's dead." Ditto Robert Mapplethorpe.

Creating a superstar takes planning, positioning and, perhaps most importantly, packaging. While we wait for Oliver Stone to take an interest in Mapplethorpe's story, the photographer's legend status continues to be repackaged each year in a growing stream of Mapplethorpe gift items, calendars, books and digital media. In 1995, the stream overflowed with a barrage of Mapplethorpe merchandise, varying wildly in quality and level of insight, and trotted out to market. Students of marketing, take note: dead superstars move product.

Listen to your coffee table. It's crying out for *Robert Mapplethorpe:*

Altars, the new large-format, slip-cased monograph of the artist's mixed-media pieces. And at a cool $100, it's a rare bargain. Like to read? Give Patricia Morrisroe's play-by-play biography, *Mapplethorpe,* a try. Not enough dirt for you? Then you might want to pick up Jack Fritscher's "outlaw reminiscence," *Mapplethorpe: Assault with a Deadly Camera* (but be warned: it's not for the timid). Perhaps you require something a little more, shall we say, highbrow? Philosopher Arthur C. Danto steps in with *Playing With the Edge: The Photographic Achievement of Robert Mapplethorpe.* What's that? Still not convinced that Mapplethorpe has earned his place in the pantheon of Twentieth Century Master Superstar Photographers? Then we've got just the book for you: *Weston + Mapplethorpe: The Garden of Earthly Delights.* It's a modern wonder of revisionist packaging.

With the market value of Mapplethorpe prints on a downward

slide, it's no wonder that the Robert Mapplethorpe Foundation has put its licensing division on overtime. As the arbiter of Mapplethorpe's estate and the steward of his legacy, the foundation naturally has a vested interest in expanding Mapplethorpe's marketability and propping up his legend. This is not to say that the legend is surviving intact. Once derived from the perceived tension between the photographer's unruly sexual persona and the slick, highly controlled nature of his art, Mapplethorpe's mystique now is being dissected and parceled off to suit the needs of targeted consumer groups.

Consider two CD-ROMs about Mapplethorpe and his work published last year by Digital Collections, Inc. These products provide a telling example of how marketing is driving the evolving dialogue about Mapplethorpe and his contribution to twentieth-century art. The first disk, *Robert Mapplethorpe: An*

Overview, goes to great lengths to present a sanitized version of Mapplethorpe as a modern-day Classicist and an unrivaled aesthete. Perhaps *An Overlook* would have been more apt a title for the disk, for the images that made Mapplethorpe a household name during the culture wars of 1989 and 1990 are conspicuously absent. In a crass attempt to make the disk acceptable to the broadest possible general audience, and to avoid a potential boycott by merchants, the producers have passed over all images that contain the female nipple, frontal nudity or allusions to sexual acts. That is to say that the lion's share of Mapplethorpe's great work is absent. What we're left with are flowers, celebrity portraits, statues and benign side-view nudes that only hint at the power of Mapplethorpe's best work. Purged of any notion of the erotic, this collection of slick, soulless images achieves the opposite of its intended effect. Instead of making a strong case for Map-

plethorpe's induction into the pantheon of master photographers, it presents a convincing picture of a photographer all too willing to compromise in deference to market-driven considerations.

Making matters even worse is a voice-over track that earnestly strains to sell an image of Mapplethorpe as one who put a love of beauty above all else. "Robert Mapplethorpe's legacy is an art of perfection, seizing exquisite moments and encapsulating them for eternity," the voice tells us. "His work goes beyond the individual subject to the universal, conveying not just a beautiful face, but the very concept of beauty itself." While it is true that Mapplethorpe certainly struggled throughout his career to define a singular vision of beauty, the details of his life suggest that his insatiable love of sex, money and fame superseded his aesthetic concerns. Arthur C. Danto, in his book *Playing with the Edge,* warns that efforts to sanitize Mapplethorpe's artistic output

threaten to make him meaningless: "To subtract from Mapplethorpe's photographs…the sense of that danger…is seriously to distort their aesthetics, and to misconceive his artistic agenda."

The companion disk, *Robert Mapplethorpe: The Controversy,* presents a more representative version of the photographer's oeuvre, and

the Mapplethorpes that shocked a nation! Be among the first to own this unflinching overview of Robert Mapplethorpe, his life and work; see his most provocative images in the comfort of your own home. Adults only, please."

By promoting these two contradictory visions of the photographer in separate packages and with sepa-

While it is true that Mapplethorpe certainly struggled throughout his career to define a singular vision of beauty, the details of his life suggest that his insatiable love of sex, money and fame superseded his aesthetic concerns.

includes a complete electronic reproduction of *The Perfect Moment,* the retrospective exhibition that became a catalyst for First Amendment rights activists and would-be censors alike. The promotional text for *The Controversy,* makes it clear that the producers are hoping to rake in the big bucks from an easily titillated general public that has, until now, only *heard* about that legendary bullwhip photograph: "View

rate campaigns, the publisher is employing a marketing strategy that Mapplethorpe himself utilized from the beginning of his career as an exhibiting artist. In Morrisroe's recent biography, she observes that the "strategy of splitting up his work was born of necessity, but it later became a staple of his career; the X-rated material gave him the notoriety, but it was the 'PG' pictures that made money, and by separating them

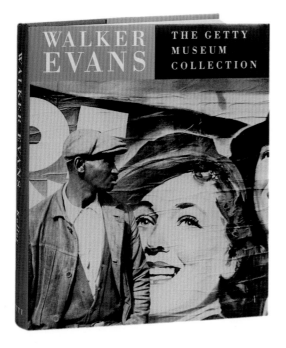

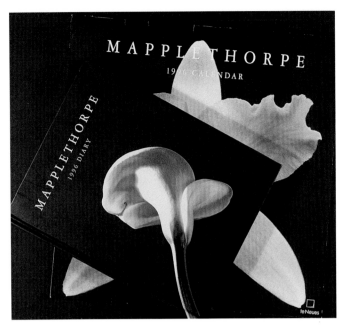

he could reach both a gay and a straight audience."

Mapplethorpe carefully positioned his work—indeed, he conceived it—with marketing in mind. Early in his career he put himself on the map by creating images so infused with radical notions of sexuality that they could not be ignored. He then purposefully distanced himself from his reputation as "the S&M photographer" and later "the gay photographer" with his austere flower pictures, still lifes, figure studies and celebrity portraits. At the end of his life, he refused to discuss his medical condition, feeling that the stigma of AIDS would undermine his reputation as an artist and adversely affect the sale of his work. Today, those that endeavor to capitalize on Mapplethorpe's oeuvre must come to terms with the fact that segregating the markedly different strains in his work will only provide fodder for his detractors. If it were not for the controversial sex pictures and the cultural maelstrom that they sparked, Mapplethorpe likely would have been dismissed after his death as an aesthetic snob and an opportunist. Instead, his legacy remains driven by his role as a cultural rabble-rouser. Danto, in a text that makes a strong case for Mapplethorpe's continuing pertinence as an artist, explains that "his political acceptability, in consequence of the martyrdom of his art in connection with right-wing attacks

on institutions that support it, has redeemed him in the politicized and judgmental eyes of an art world whose values are otherwise so antithetical to those proclaimed by his style and typical subject."

Morrisroe's biography is replete with observations about Mapplethorpe's well-orchestrated march toward fame and success, and it amply provides the juicy anecdotes that readers of biographies love so well. In some respects, the author has positioned Mapplethorpe as a leather-clad Forrest Gump, in that the excesses of his life have been repackaged to personify his times. In a promotional interview for the biography, Morrisroe encapsulates her premise: "He grew up in suburban America in the 1950s; moved to Manhattan in the height of the '60s—the week of the Stonewall Rebellion; embraced drugs and extreme forms of sex in the '70s; transformed himself into a 'product' during the money-mad '80s; and died of AIDS at the end of the decade." The biographer's synopsis, itself a shrewd piece of repackaging, is consistent with the tone of her book. But the biography adds little to the critical dialogue surrounding Mapplethorpe's work; instead we are presented with an achingly human portrait of a man whose style and ambition obscured a fragility and a constant need for affirmation.

Jack Fritscher's self-proclaimed "outlaw reminiscence"

of Mapplethorpe, *Assault With a Deadly Camera,* has fewer redeeming qualities. Fritscher, one of Mapplethorpe's lovers during a three-year period in the late 1970s, has claimed the photographer as an icon of "a golden time before AIDS and its lost civilization beneath a viral sea." For Fritscher, the time was "golden" because he and Mapplethorpe, as part of a subculture that was becoming more strident with each passing year, could still whet their appetite for decadence with abandon and perceived impunity. Fritscher's book is by no means a biography, but it is intended to set the record straight about Mapplethorpe once and for all: "To the degree that his art serves as a litmus test of the continuing American *fin de mille* debate between the just-say-no national character of denial and the individual right to choice, Robert, as a person and as an artist, has been misrepresented in the sound and the fury." With this promise to show us the *real* Mapplethorpe, Fritscher continues: "This memoir intends to present some evidence that once there was a living, ambitious, sensually playful, scared, intelligent human being who, one day, finding a camera in his hand, looked through the viewfinder, like a gypsy with a first crystal ball, and saw the chance to focus his instamatic visions."

In spite of such heartfelt eulogies, and due to the efforts of a growing army of spin doctors, seven years after his death Mapplethorpe

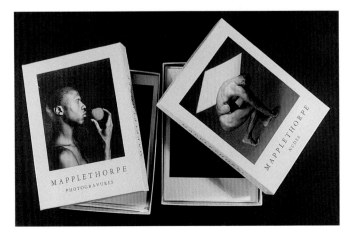

From the CD-ROM *Robert Mapplethorpe: An Overview.*

and his art seem more confounding than ever. Yes, he's hot, sexy and dead, but it still remains to be seen how much more repackaging his legacy can withstand. A definitive text, one that accommodates the difficult idiosyncrasies of Mapplethorpe's artistic legacy without pandering to the photographer's legend status, has yet to emerge. Perhaps it is only natural that this critical framework has been so long in coming; after all, Mapplethorpe's fame as a household word has owed more to political controversy than a national debate on aesthetics. Those who are drawn to Mapplethorpe's fame as a cultural terrorist and a raconteur are running out of tales to exchange about the artist's legendary appetites. Those who are drawn to the powerful tension between the beautiful and the profane in his art are still straining to find a place for his work within a contemporary dialogue in which certain political attitudes are *de rigueur.* Will the twain ever meet? ▽

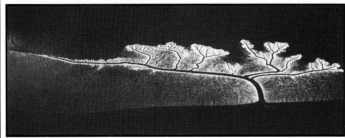

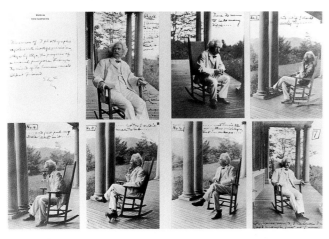

Albert Bigelow Paine, *The Development of Moral Thought,* 1906 from *Literature and Photography.*

IN
PRINT
Looks at books

Plot, action and accident

Literature and Photography,
Interactions 1840-1990
Jane M. Rabb, ed.
University of New Mexico
Press, 1995

Review by Eugenia Parry Janis

Flaubert's realist novel *Sentimental Education* was discredited as a "collection of photographs." Pound dismissively scrawled "photography" on the manuscript of Eliot's "The Wasteland." Weston criticized soft-focus pictorialism as "the by-product of literature." And Baldessari wrote, "Learn to Read. Learn to Write" across his journal. These clashing intersections of impatience, insight and desire emanate from *Literature and Photography, Interactions 1840-1990,* Jane Rabb's splendid chronological compilation of one hundred writers' texts on photography.

The selections make superb reading, and Rabb's intelligent, meticulously annotated commentary allows readers to explore camera work beyond the patents, priorities, recipes and personalities that characterize much photographic history. Through writers, Rabb proposes a new kind of history, an alternative to

Modernism's insistence on photography's visual purity. This refreshing approach challenges the reputed wisdom of current photo history's tedious and often clumsy revisionism.

Avedon insisted that pictures were "fictions," as if that were news. Writing, an older art used to "slanting evidence," as Rabb explains, has known this all along. By showing the ways writers found photographs fictive and created fictions from them, her book fulfills everyone's craving for stories. Many of these stories about photography offer stunning new discoveries, plunging readers into rewarding complexities and contradictions that deepen an understanding of photography's effect on the imagination as never before.

Sartre observed, "Photographs are not ideas. They give us ideas." The authors—connoisseurs of plot, action and accident, experts in characters' physiognomies and motivations, and in the secret ironies of time and place—discover in the album, snapshot or x-ray arenas of conflict, mockery, loss, love, jealousy and mystery that summon the darkened halls of memory. No history of the medium so thoroughly confronts its readers with photographs as emblems of feeling or extensions of the mind.

These texts do not situate the story-generating power of photographs at a single starting point, the way photography's scientific histories begin with inventors Daguerre, Talbot and Bayard's necessary devotion to objects. While the first photographers were fearful of not achieving any picture at all, their contemporary, Balzac, compared being photographed to the trauma of being robbed of "spectral layers" of the self. He enjoyed the terror of thinking that subsequent portraits eventually would succeed in eliminating the sitter altogether. Similarly, the superstitious landlady of Holgrave, Hawthorne's daguerreotypist, suspected him, in his lonesome chamber, of practicing animal magnetism, or the Black Art. And Poe wrote predictably, "It is the unforeseen on which we must calculate most largely!!" The unforeseen engulfs Emerson and Carlyle, trading daguerreotype portraits of themselves. Emerson discovers in his face "the air of a decayed gentleman touched with his first paralysis." Carlyle laments, "O my friend, it is a strange Phantasmagory of a Fact, this huge tremendous World of ours, Life of ours!"

On photography's transformation of fact the writers are prolific. Twain quips, after Sarony turned him into a gorilla, "The camera is the only witness I couldn't bribe." Kafka sees in an instrument so consumed by externals not a "Know-Thyself," but a "Mistake-Thyself." Many writers dote on the legendary beauty of "the pictured face," the complete sufficiency of mere identity, according to Faulkner. Ginsberg praises it as a "sacramental presence." Paz observes that "the face of reality, the face of everyday, is never the same face," reaffirming that Stieglitz's portraits of O'Keeffe only collectively reveal the truth of the sitter. Novelist Michel Tournier comments that "Anyone who is afraid of having his or her photograph 'taken' is only showing the most elementary common sense. It is a method of consumption. . . .If beautiful landscapes could be eaten they would be photographed much less." Which also throws light on O'Keeffe's revulsion at being devoured, having been photographed so much.

"Observation is a kind of interaction that beclouds itself," notes Updike, quoting the physicists. Many writers recognize this beclouding as the essence of visual thinking, which they have no trouble linking to imagining. An earlier writer like Ruskin, who copied daguerreotypes, surprisingly celebrates photography's "luminous decomposition," a conception that found self-conscious footing only later in the century when artists explored pictorialism, and writers like Mann in *The Magic Mountain* had photographs unlock "secrets of the bosom." As his character Joachim is being x-rayed, Mann writes, "We must first accustom the eyes…get big pupils like a cat's, to see what we want to see… banish daylight and its pretty pictures…wash our eyes with darkness." Gazing at the finely turned skeleton of his own hand, Joachim "for the first time in his life… understood that he would die."

"Always we are aware…that something lay beyond the edges, in…space and time.…Our knowledge that something lurks just beyond the edge of exposure is ominous," Updike writes. Mining pictures for fictions outside the frame attracted writers to photographic albums, which many considered "the best reading in the world." Chekhov wrote a story about a retiring functionary presented with a commemorative album of his employees' portraits. After weeping joyfully, he consigns the sacred gift to his daughter, who replaces the portraits with those of her friends. His son then paints the rejected pictures red and green, pokes them with pins, and pastes the effigy of one employee onto a match box, in a new "monument" praised by the whole family who forgets the once-prized album. Tolstoy dramatizes love gone sour by having Anna Karenina compare album photographs of her little boy at various ages. Discovering among them one of her lover Vronsky, she uses it to dislodge the best photo of her child that was stuck in place. Seeing Vronsky's photographed face fills her with love, but when the living subject arrives and loses himself in the boy's pictures, ignoring her, she

see **62**

snatches them from him, "significantly…with flashing eyes."

Photographic transportations into delusion absorb writers like Nabokov, in whose work photographic asides abound. In a poem called "The Snapshot," he becomes an "accidental spy," caught in the background of someone's summer seaside picture. He imagines it viewed the next winter in an album shown to a grandmother in an unknown house, where his stolen shade becomes a "likeness among strangers." With the same recognition of photography's invasion of fears and wishes, Proust in *The Guermantes Way* becomes the unseen observer of his vacant grandmother, recording her in his mind's eye like a camera devotedly concocting an ideal. "We never see people who are dear to us save in the… perpetual motion of our incessant love for them." Proust's eye, "charged with thought," is unable to reconcile him with the harsh truth of the actual grandmother, now "dull and changed."

As writers fearlessly projected convoluted imagining into photographic recording—unlike photographers, for whom the thing itself became sacred and inviolate—they recognized the usefulness of an object's ability to function as a generality. Henry James wanted Coburn's photographic illustrations of his collected works to be "echoes, expressions of no particular thing in the text, but only the type or idea of this or that thing," a rendering around the mind of his story. Such notions contradict E.M. Forster's praise of the photographic click that says, "So that's it," or "How like that." For many in this book, photographs are natural resources, there for the taking. "A lesson for any writer," Kerouac writes, " . . . to follow a photographer and look at what he shoots. … I mean a great photographer, an artist…and how he does it."

Jane Rabb offers a rare gift to artists and scholars of every stripe. It is exciting to follow Conan Doyle into spiritistical apparitions, Wright into the camera's relation to black power, Brecht into war through quatrains in his *War Primer,* and Ondaatje into Belloq's isolation ("You know he even talked to his photographs he was that lonely"). Inspired by this scope, readers may discover how narrow the perspective of photographic history has been without taking into account the writer's share.

Think back to when, for lack of anything better, Sontag's *On Photography* was gospel, and Barthes' *Camera Lucida* seemed to grasp photography's essence as a form of language. Now these writers have a proper context. Their tradition, old and great, has been so scattered as to seem nonexistent. Collected in this large, broadly-ranging volume, it is back in full strength. We should rejoice. ☞

Scaling Mount Adams

**Ansel Adams and the American Landscape: A Biography
by Jonathan Spaulding
University of California Press, 1995**

Review by Douglas R. Nickel

Let's admit it straight off: Ansel Adams is the sacred cow of photography. Asked to name a famous photographer, the average person on the street will mention Adams often without being able to name even one other photo artist. The only photographer to appear on the cover of *Time*, to have bestowed upon him the Medal of Freedom, to wrangle with American presidents—Adams has become our National Treasure, a Walt Whitman of the camera in boots and Stetson, hero to shutterbugs and environmentalists alike. Not surprisingly, a host of ironies accompany this popular image: Adams' early expressions of contempt for the gallery-going public, the use of his photographs to sell coffee and B-1 bombers, his big cars, his prints drying in the microwave, etc. Perhaps the grandest twist of all is that, having contributed so much to making

photography a subject of institutional and common regard, no one really talks about either Adams' pictures or the significance of his career. The ubiquity of Adams' imagery seems inversely proportional to the thoughtful analysis his life and work have received, the big shadow of his persona effectively blotting out the substance of his creative achievement.

This situation may in part be attributed to the tight grip Adams' friends and former employees have maintained over control of his image. There is no lack of literature on Adams, only a lack of critical distance between Adams and those granted stewardship of his words and pictures, and therefore his reputation. The photographer's own 1985 autobiography was preceded by his friend Nancy Newhall's 1963 biography, *The Eloquent Light,* and followed by such posthumous productions as *Ansel Adams: Letters and Images* that provide heavily-edited glimpses into the life underlying the myth. Other than the anomalous *Ansel Adams: New Light* (The Friends of Photography, 1993), Adams studies thus far have been closed-shop operations. The goodwill of his guardians notwithstanding, Adams' place in photographic history remains pretty much an open question.

One would think that Jonathan Spaulding, a young scholar coming from outside the Adams inner circle, might seize the opportunity to deliver the first full-length critical appraisal of Adams brought forth free of these ministerial fetters. Spaulding's *Ansel Adams and the American Landscape:*

A Biography, it turns out, is neither critical nor all that original. Spaulding has collated information, chiefly from letters and the available publications, into a narrative that dutifully follows Ansel from San Francisco boyhood to adult career to Carmel retirement, without straying far from the official script. The book's intended novelty—to interweave a cultural history of twentieth-century attitudes towards nature and the land, and specifically the Sierra Club and National Parks policy, with Adams' involvement therein—in theory could have served as an excellent vehicle for delving into what it was that actually made the man tick. Adams was a figure well aware of his own conflicted identity, which showed itself not only in his seemingly patternless environmental philosophy (sometimes fighting wilderness exploitation, sometimes accommodating commercial interests, eventually breaking with the Sierra Club over his support of nuclear power), but in every aspect of his life.

A bourgeois bohemian, an absentee family man, a latter-day Romantic simultaneously seeking and reviling commercial success, a showman who thought Edward Steichen "the anti-Christ of photography" because of his thoroughly effective showmanship—here is a personality demanding some unpacking. Spaulding's decorous treatment, however, takes all the rough edges off his material. While occasionally acknowledging the contradictions apparent in Ansel's mental universe, the author seems content to reflect Adams' confusion without sorting it out or commenting upon it. Is it possible that Adams considered his 1950s work for Kennecott, the largest open-pit copper-mining operation in the world (Spaulding prefers the euphemism "extractive resource industry"), a bread-and-butter assignment ethically indistinguishable from any other? Does Spaulding? Readers might come away from this account believing so.

The lapidary handling of the text extends to Spaulding's writing style. The effect is to make Adams' life seem duller than it was, and the

issues surrounding his work less acute than they really are. This is too bad, for Adams was a major player in American photography: his involvement with the f/64 group, his ideological bone with pictorialism, his direct role in the formation of the Museum of Modern Art's photography department, his construction of nineteenth-century exploration photography as a kind of proto-modernism, his transcription of Stieglitz's vitalist philosophy into Western photographic syntax, his ambivalence towards documentary—these all are topics that warrant thoughtful consideration and research. And there still is the matter of the photographs: how

might they stand up to various (psychological, iconographic, semiotic) readings? Spaulding was denied permission to reproduce Adams' images, which may account for the want of visual analysis in his study, but a consequence of continued inattention to the work itself will be that Adams gets remembered as a personality rather than as an artist. Since history has a way of turning even household names into names no one recognizes, we can hope only that scholarship more impressive than Spaulding's emerges and finds support. If not, the fate of photography's sacred cow may well fall to taxidermists. ☿

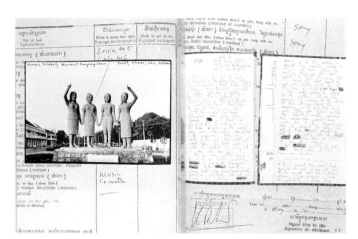

Bill Burke, from *Mine Fields*, 1995.

Spiritual housecleaning

Mine Fields
by Bill Burke
Nexus Press, 1995

Review by Michael Read

In October 1991, Cambodia's warring factions signed a peace treaty in Paris, thus ending a 16-year civil war and defusing the brutal regime of the Khmer Rouge. Twelve months earlier, in Massachussetts, photographer Bill Burke was unceremoniously kicked out of his house and sent into exile by his wife. A coincidence?

Burke's latest book, *Mine Fields,* wastes no time in setting up this uneasy juxtaposition between a sloppy divorce and one of the bloodiest wars of the twentieth century. Pol Pot's revolution and its devastating

aftermath had left over one million Cambodians—or one in seven—dead from starvation, disease and genocide. Burke's divorce, he'll have us know, cost him more than $40,000.

While many readers may bristle at this callous analogy, it is this type of unapologetic disclosure that makes *Mine Fields* a remarkable and in many ways unprecedented treatise on the creative process and the construction of personal metaphor. Composed primarily of diary entries, ephemera and austere black-and-white photographs, the book traverses the dangerous territory between emotional displacement and external chaos. In Burke's private universe, image-collecting has become a process of psychodrama. As with many forms of therapy, the procedure is not always easy to stomach.

The photographer made his first trip to Southeast Asia in 1982, he tells us, "partly to see the region that had played such an important role in recent U.S. history, and partly to get away from the relationship I was finding increasingly confining and oppressive." After instituting annual trips to the region, Burke began to gravitate toward areas of potential incendiary conflict, particularly along the Thai-Cambodian border and nearby Khmer Rouge encampments. True to his documentary credentials, he was victim to a compulsive habit of going where he shouldn't go and photographing what he's not supposed to see.

Through a series of engrossing, handwritten diary entries, readers are privy to the development of an intense, dysfunctional relationship between Burke and the elusive Khmer Rouge. In one sense, Burke was a photographic big-game hunter; we witness as he tiptoes around land mines, is arrested and interrogated by military officials, and exposes himself to one potentially catastrophic situation after another. In one entry he muses, "Out of five days of effort, two arrests, many thoughts of being shot as an intruder, several kilometers of walking on what I feared to be exploding ground, I can only remember a single picture that might have been worth taking." This admission underscores the fact that Burke's motives are murky even to him. Nonetheless, it is this same ambiguity that makes *Mine Fields* a complex and ultimately fascinating experience for readers. In less skillful hands, this apparent lack of purpose might be considered a weakness, but Burke capitalizes on his creative restlessness and makes it one of the book's major themes.

Interestingly, Burke's photographs are firmly rooted in traditional documentary standards. They communicate effectively about the human cost of war, but his book is by no measure a pat condemnation of war, or even a call for peace. Burke makes no bones about the fact that his journey is first and foremost a foray into his own heart of darkness. "Although the last week has been full of frustration and fear," he writes, "I remind myself that a bad day here is better than a good day at home." We have to wonder if that sentiment applies to the day his neck was broken in a bus accident that left several people dead, an incident about which Burke is circumspect. "The worst aspect of breaking my neck was that the trip was over," he scrawls on a found image of a political prisoner held captive by a medieval-looking wooden collar, "replaced with the feeling that I was going home to jail."

Burke's home life, we're led to believe, was the real battlefield. The enemy here was armed not with automatic rifles but with court orders. We share the photographer's recognition that he was more at ease when confronting the perils of guerrilla warfare than the self-imposed mine field of a marriage ruined by neglect. By page seven, the compulsive documentarian is spying on his wife from a cardboard box in the back of a station wagon. "I am waiting to video tape my wife and her boyfriend packing half of our possessions into a moving van," he writes in his diary as he waits. "When the van leaves and the locksmith comes again, I will move back into the house and begin to reassemble my life." Even on the familiar turf of his own home, Burke cannot resist this bizarre act of personal documentation.

As it turns out, documentation, whether in the form of diary-keeping or the act of collecting images, is integral to Burke's process of healing. The book ends with a poignant passage detailing the photographer's reentry into the world of the sane and rational. His wife finally disembarks with the dogs and her portion of the divorce settlement, and Burke finally is free to begin rebuilding. To fulfill his need for metaphoric passage, he invites an entourage of monks from a nearby Buddhist congregation into his home to perform a ritual known as "spiritual house cleaning." Afterwards, he writes, "I am filled with good feelings about the future and confidence in my ability to observe most of the rules easily."

Thankfully, it is doubtful that Burke will extend his desire to live by the rules to his photographic endeavors. With his contemporaries Larry Clark, Jim Goldberg, Nan Goldin and Larry Sultan, to name but a few, Burke is effectively dismantling the worn-out popular conception of the documentary photographer as a selfless, socially-concerned provocateur.

Theirs is a practice that brings the diaristic impulse out of the closet and places it front and center within the documentary process. Finally, perhaps, documentary photography is beginning to fulfill its promise by showing us not just what humanity looks like, but what it means to be human. ☿

← →

Mythology of self

Diary
by Peter Beard
Tokyo: Libra Port, 1993

Review by James Crump

The books have something to them, but I don't know really what yet. It's funny that the two things I love most—collecting stones and doing diaries—are equally meaningless.
—Peter Beard

When photographer, naturalist and all-around raconteur Peter Beard was growing up, his mother kept him away from play until he'd entered the previous day's activities in his journal. It was a discipline that eventually consumed Beard, so much so that now, in his mid-50s, he calls himself a "diarist." As a record of his perilous encounters with the forces of nature, the pretentious details of his jet-set lifestyle, and of the inexplicable disparities of life faced by Africans, Beard's journals are a melange of searing documents combined with the ready-made eccentricity of a dada collage. As Beard readily concedes, it is difficult to know what meaning these fragments of one man's life might reveal to the reader. One wonders if in fact they are an "important chronicle of these times," as one of Beard's dealers confidently asserted, or simply the self-obsessed meandering of an overly-active and eroticized mind.

Beard long has seen himself as one of the beautiful bad boys of his generation. Around 1960 he retreated to East Africa, now his adopted

home, and left behind a more prosaic, albeit privileged life in Manhattan. His was a boyhood dream of the colonial past, a time evoked in the novels of Joseph Conrad and in the romanticism of Karen Blixen, whose pseudonymous *Out of Africa* he repeatedly devoured as a teenager. In fact, *Out of Africa* became Beard's bible, an utopian model for living amidst all the danger and beauty the wild had to offer. The white man's safari likewise had its appeal. The thrill of being face to face with a charging rhinoceros was matched only by the base-camp storytelling Beard shared with the "great" hunters of an earlier era, or the ubiquitous phalanx of fashion models vying for the photographer's attention. The outlandish stories of Beard's adventures in Kenya and other parts of the African continent are well known. They form a mythology now buttressed by Beard's meticulous diary-keeping. The diaries suggest a life of contradiction, built upon Beard's genuine efforts to restrain the destruction of wildlife and natural resources, but nevertheless undermined by the air of his uncontrollable narcissism. *Diary* is the culminating record of an egocentric's life lived with utter abandon.

Beard once saw an airplane crash in Connecticut in which 11 people were killed, their wallets and personal belongings strewn about, layer upon layer, in the craft's wreckage. This haunting image infuses *Diary*, a collection of bygone objects and curios that once supported life but now are relegated to interment. Beard has left nothing

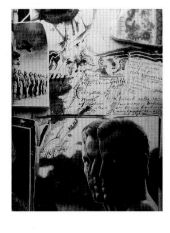

Peter Beard, from *Diary*, 1993.

out: matchbook covers, buttons, condoms, feathers, rocks, spent bullets, snapshots, taxi receipts, concert tickets, blood, spit and other bodily fluids. Working for extended periods of up to eight hours and longer, Beard fills the diaries' marginalia to capacity with phone numbers, addresses, names, dates and recollections, all painstakingly scribbled down with India ink. Bound in 11 x 14-inch artist sketchbooks, the real diaries close like an accordion, with pieces of things oozing out from the inside.

Diary has Beard revealing its pages as if the viewer actually were in his presence. We see the diarist's ink- and bloodstained hands, tattered and callused, holding open the pages. In another segment, Beard's reservoir is filled with ink as he sets pen to paper. Such heroics are superfluous, however, as the diaries can and should speak for themselves. Further, the editing and sequencing of this beautifully produced book often weaken the potent emotion that Beard's images are capable of producing.

Recalling the now-legendary 1967 monograph *End of the Game*, from which a great deal of photographs have been reappropriated for these diaries, this book is burdened by an emphasis on Beard's penchant for tits and ass, and the occasional nude prepubescent girl. Gone are the harrowing aerial photographs of elephant carcasses, landed crocodiles, and the energy pursuant to Beard's mad rush to return Kenya to its colonial state.

Beard never let go of his idols—embodied in the likes of Denys Finch Hatton, Tiger Marriott and Philip Percival—believing that the greatness of minds gathered in Kenya in the first quarter of this century would create the idyllic multi-culti community. Whites would peacefully cohabit with blacks and native culture would allow for Anglo-European integration.

Beard is at his best as a diarist when he exposes, perhaps unintentionally, something far more troubling, dark and sinister than most pages suggest. He uses the refuse of human existence, discarded steel, rubber and chemicals permanently staining the land as his visual vocabulary of immediacy. But too often the book opens to a bare-breasted Parisienne, reclining like an odalisque, while on another page we see the frightening details of a young woman's clitoridectomy. Beard isn't shy about his preoccupations, or about showing us how banal his life is, and how little the material shards add up over time. Doubtless Beard's diaries eventually will possess the aura of artifact. Years from now, they will achieve the time-capsule effect of revealing the superficial and ephemeral nature of our troubled existence. ☿

From *Bad Mojo*, 1995.

SOUND AND VISION
Musings on multimedia

Playthings: *Bad Mojo, Dogz* and *Teo*

By Ken Coupland

Let's consider for a moment that peculiar hybrid, the CD-ROM game. Perhaps, like a few of us, you've proven immune to the charms of the kind of interactive puzzle-solving typified by *Myst,* last year's runaway multimedia hit that enticed players into a treasure hunt for clues to a terrible secret on a mysterious island. Unlike more conventional games—think Scrabble, baseball and Hearts—*Myst* offers a static, solitary pursuit; the electronic brain-teaser can take days of solo play to untangle. Nevertheless, the cult adventure hooked swarms of gamers, spawned a yet-to-be-released multimillion dollar sequel, and evidently got a lot of people in the CD-ROM industry thinking.

A new batch of CD-ROM games picks up where *Myst* left off, taking full advantage of multimedia technology that offers possibilities only dreamed of by *Myst*'s creators. A spectacular example is The Residents' *Bad Day on the Midway* by San Francisco artist Jim Ludtke, which features three-dimensional exploration and random plot juxtapositions that fleetingly approximate the experience of virtual reality and point the way to the creation of truly immersive realms in game design.

But while software innovations continue to outstrip the wildest technological expectations, production times grow longer and longer as projects become more ambitious and complex. If you're creating works in the exciting new field of multimedia, that CD-ROM title you're planning to publish likely will be obsolete by the time you release it. CD-ROMs themselves no longer seem like the wave of the communications future; the Internet now owns that rather dubious distinction.

Bad Mojo, another San Francisco production, exemplifies the format's maddeningly swift rise and fall as a media standard. With its superior production values and multimillion dollar budget, *Mojo* shows off virtuoso rendering and evocative ambient sound; there's even a dramatically effective video narrative, which is more than you can say for the average CD-ROM game. *Mojo* reeks of urban blight and industrial decay, and its savvy appropriation of nondescript Machine Age gadgets, packaging and other memorabilia heightens the game's *noir* allure.

The "mojo" of the title is a mysterious amulet with the ability to transform the game's erstwhile hero into a loathsome insect, but that's somewhat beside the point. Never mind that the tale loses something in the telling; it's the game's structure and design that matter most. (One lesson the game's designers didn't learn is that for a story to fully work, characters need to be at least a little sympathetic.)

Unlike, say, the irritating and overpraised *Seventh Guest* and its ilk, *Mojo*'s puzzles are an organic part of the journey. Your agent is a sickeningly realistic animated cockroach. Players cursor the beast through a stupefying number of meticulously rendered frames. These scenes take the shape of free-form mazes through which you are required to navigate, avoiding a host of threats to your insect life.

Perhaps the most ingenious feature of *Mojo* is a recurring type of puzzle that requires you to figure out how to manipulate elements on the screen that can serve, for instance, as bridges to areas of safety. These require tasks that a cockroach could at least hypothetically hope to perform, like pushing relatively lightweight objects into positions that create electric short circuits or various mechanical functions. If you loved high school science projects, this game might grab you.

For all of its distinct qualities, *Bad Mojo*—two years in the making—also is something of an artifact. *Mojo*'s 2-D displays make you hunger for the more seductive thrills of 3-D modeling. Ultimately, however, it's in the missing element of multiple play—a gaming format already being explored in online prototypes—that *Mojo,* worthy and inventive though it may be, is tied firmly to its place and time.

While *Mojo*'s cockroach serves as your stand-in or avatar, functioning very much like a piece to be moved around a virtual board, another new game design genre that borrows from the "intelligent agent" model currently offers more intriguing, albeit troubling thrills. Depending on how you look at it, *Dogz* either is the screensaver from hell or an inventive exercise in time-wasting. Capitalizing on the vast popularity of various programs originally designed to keep long-displayed images from burning into the computer screen (and, despite their increasing popularity, no longer necessary with today's computers), *Dogz* provides a perfect excuse to avoid getting back to work on that term paper or spreadsheet for which you bought the computer in the first place. The software's cloyingly cute canines romp around onscreen, reacting to how their owners treat them, learning tricks and eventually molding themselves to their human keepers' personalities.

There's something creepily absorbing about this concept, which pops up again in the even more curious *Teo: The Other Earth,* a Japanese production recently on display at U.S. trade shows. Commercially available only in Japan, where customers are faced with the unenviable option of purchasing add-on voice recognition hardware to run it, the eerily ingratiating program features a fetus-like flying dolphin (imagine a puppyish homunculus). The little fellow grows up along with you, adapting much the same way as the canines in *Dogz.* Even when the computer is turned off, the infernal thing keeps evolving. *Teo*'s mascot also is slightly neurotic; if you speak crossly to it, the critter flies away and hides for a while. Screensaving never seemed so complex, so fraught with the tensions and extremes of human emotion.

With the bulk of multimedia mired in predictable, predigested content and presentation, and a lot of charmless kids' titles cluttered with obnoxious characters and grating narration, it's nice to see a few game developers introducing novel programs for children that harness rudimentary artificial intelligence to simulate learned behavior, even personality development. If Fujitsu decides to distribute *Teo* worldwide, kids may never finish their homework again; they'll be too busy teaching the dolphin to conquer its fears and develop social skills. 𝍦

Continued from page 21

The absence we see in these images is not in their world but in ours. This is, among other things, a way of looking at the blind less as victims, in terms of their lack, but rather as different, a perspective that underscores the fragility and contingency of our own vision. These images suggest too why the blind make us uncomfortable. It is popularly supposed that we feel pity for their exclusion from our ocular world, but these images propose instead that the blind somehow intimate that our world doesn't necessarily exist. It is our own condition, not theirs, about which we are anxious.

In his photographs taken at the Perkins School for the Blind, Nicholas Nixon seems to be trying to describe the nonvisual realm of the senses. The tactile phenomena—touch, the quality of the skin from the newborn to the dead—that have been the implicit subjects of so many of his other portraits here become the explicit subject. A child runs her whole hand across the bumps of a page of Braille; another girl presses her face against a printed book on an easel as though to absorb the words directly; a boy bends over his fingers on a piano keyboard; a woman tucks her chin into the crook of a child's neck as he reaches back at her. Hardly a face points directly at us, or even poses on a level or faces forward. These faces are tactile apparatuses, carrying with them hearing, smell and taste, and they would be doing the same

thing were there no light at all. The photographs themselves are casual about the visual elements of light and composition, suggesting that being photographed for this series was a non-event, save for one girl who waves in response to what must have been a verbal instruction. These children are strangely sensual, living without the most disembodied, coldest sense of the surrounding world; our senses other than sight make much more visceral contact with the body. Nixon pushes us past our evaluation of his subject's appearances and blindness to an empathic absorption in their other senses. As his photographs show, these children encounter much of their world at a range at which things are not clearly visible anyway—up close. Nixon's are images of sound, touch, feel, smell and taste, as though a world without vision were a world full of sensual lack of distance, of an immediacy from which we are locked out as onlookers. These photographs suggest that we have lost a great deal by embracing the domination of the ocular; these are pictures not only of the blind children's lack but also of the viewers', and of the visual world's.

That love is blind is a truism usually interpreted to mean that love has a threshold of ignorance or unknowing; Nixon's images inspire a different reading for the phrase. The children in his photographs are tenderly cared for, as the many gestures of contact indicate, and they seem to

see

T

m l xl
white black gray

100% cotton	$15* + $4 postage and handling
see tee, 250 Fourth Street, San Francisco, CA	
*CA residents please add applicable sales tax	see

Continued from page 69

live in a world of what is close at hand, and bring to that closeness a tender absorption that the mobile, fickle sighted lack. Nixon proposes that blindness is, under certain circumstances, love—a love that is a quality of enduring attention and sensual immediacy. And he proposes an operation for photography familiar from Rimbaud's synesthesia and Stieglitz's *Equivalents* series: that one sense or subject do the duty of another, that sight tell us about smell and touch and feeling, just as Stieglitz insisted that clouds stand for emotions. They are in some ways Nixon's most conceptual images, self-conscious about the nature of this most purely visual of media and about the limits of sight and explicit about his ongoing interest in touch and tactility.

Sophie Calle's series *Les Aveugles* explicitly asks us to rely on text for meaning, as Nixon's and Mark's ask us to peruse titles for context and explanation; it is language as much as vision that we depend upon to understand these projects. Calle's project in many ways is in perfect opposition to Nixon's. *Les Aveugles,* a series of more than twenty portraits each accompanied by another photograph and a framed text, isolates Calle's subjects, formalizes their communications and pushes them toward visuality. Each subject apparently has been asked what she or he thinks is beautiful; their statements and Calle's own photographic interpretations of the things they name complete each trio. Just as Nixon showed us a world seemingly complete without vision—which makes us see what we fail to experience in being con-

sumed by the visual—so Calle pushes at the absences, desires and beliefs of the blind. One subject's husband is said to be handsome, another dreams of seeing his son, a third wishes to see a starlit sky, a fourth feels rather than sees a painting to appreciate it. Others describe a beauty that is not visual, or reject it altogether.

When I first saw Calle's series, I was bowled over by the sense of beauty it conveyed. Not until much later did I realize that the subject's statements, more than the rather pedestrian photographs of saints and seas and sheep, made the project so moving. Ultimately the images are more about communicative issues—philosophy, language, hearsay, trust, membership and exclusion—than about visuality. As usual in Calle's work, she supplies us with photographs whose meanings come from an accompanying narrative, and asks us to take on faith that the relationship between the two is genuine; in her work we ourselves are dependent on blind faith and the artist's guidance. It seems, moreover, very French and postmodern that the truths Calle reveals are those that literally are socially constructed, rather than those that exist independently. The images accompanying the portraits in *Les Aveugles* are of things whose tremendous beauty is not intrinsic, but invested. That is to say, beauty exists in this project as an invisible *something* unsteadily balanced on the tripod of authorship, intention and object, rather than as concrete things which can be seen. Beauty itself exists here in the time of darkness, coming into being in contemplative rather than visual time. ᴥ

CONTRIBUTORS

BOBBY NEEL ADAMS, a recent emigré to New York from San Francisco, has been on assignment throughout the world as a photographer, and has widely exhibited his *Photo-surgery* series. Adams currently is at work on *Seeds of Carnage,* a book of photographs uncovering land mines worldwide.

CHRISTOPHER BROWN is a widely exhibited and celebrated painter who engages the visual language and imagistic techniques of photography in his chosen medium. Brown is represented by Campbell-Thiebaud Gallery, San Francisco.

DAVID CHANDLER is a writer living in Australia. With Doug Niven and Chris Riley, Chandler has investigated the legacy of the Khmer Rouge revolution and S-21 prison, and has written extensively on this chapter in Cambodian history.

KEN COUPLAND writes about fine arts, design and emerging media technologies. He is a regular contributor to *Wired* and a contributing editor to *Graphis,* and cowrote *The Multimedia Home Companion: A Guide to the Best in Interactive Entertainment* (Warner Books, 1994). Coupland's article on multimedia programming appeared in Issue 1:4 of see.

JAMES CRUMP is a Santa Fe-based critic and frequent contributor to see whose publications include *F. Holland Day: Suffering the Ideal* (Twin Palms, 1995), *Harm's Way,* a book of photographs edited by Joel-Peter Witkin (Twin Palms, 1994) and *George Platt Lynes: Photographs From the Kinsey Institute* (Little, Brown, 1993).

TODD GRAY is an artist and educator living in Los Angeles. His work is in numerous international public and private collections, and he is represented by Shoshana Wayne Gallery in Santa Monica, California. Gray teaches at Pomona College in Claremont, California. *Michael Jackson Reconsidered,* adapted for this issue's *Open Space,* is part of a work-in-progress publication in collaboration with San Francisco designer James Lambertus.

LEJAREN À HILLER (1880-1969) influenced the direction of advertising art by incorporating photography with painting and other media as early as 1906. Much of Hiller's work is archived at the Visual Studies Workshop Research Center in Rochester, New York.

EUGENIA PARRY JANIS has written and lectured prolifically on the history of art and photography for nearly thirty years. She taught at Wellesley College from 1968 to 1986 and at the University of New Mexico from 1987 to 1994. Janis presently lives and writes in Santa Fe, New Mexico.

TOBEY KAPLAN has been writing poetry and teaching in San Francisco for nearly two decades, and for many years has been an active member of California Poets in the Schools. She teaches at Ohlone Community College in Fremont, California. Kaplan's poem in this issue originally appeared in *Snow We Might See in the Desert* (California Poets in the Schools, 1992).

DAVID LEVI STRAUSS is a New York-based critic and poet whose articles on aesthetics and politics have appeared in publications such as *Artforum, Art Issues, Parkett* and *The Nation.* He currently is collaborating with Bobby Neel Adams on *Seeds of Carnage,* a book that furthers their investigation of land mines explored in this issue.

EVE LINNAP is an artist and curator living and working in Tallinn, Estonia. From 1988 through 1992, she directed "The Directory of Estonian Pho-

Eve Linnap

tography," a project for which she formed a collection of contemporary Estonian photography. Linnap is on staff at the Centre for Contemporary Photography in Tallinn, and teaches at Tallinn Art University.

PEETER LINNAP is an artist, writer, teacher and curator in Tallinn, Estonia. In addition to having his photographs featured in exhibitions throughout Europe, he has written hundreds of articles for international publications, and authored *Borderlands: Contemporary Photography from the Baltic States* (Glasgow, Steetlevel, 1993).

C.T. McCLUSKY was a self-taught artist who, when not working as a circus clown during the 1940s and '50s, assembled collages depicting life under the Big Top and in the rapidly changing world around him. McClusky's works have not yet been widely exhibited.

DOUGLAS R. NICKEL is the Associate Curator of Photography at the San Francisco Museum of Modern Art. His review of Belinda Rathbone's *Walker Evans: A Biography* appeared in issue 1:4 of see.

LEAH OLLMAN writes about art for the *Los Angeles Times* and several other publications, including *ARTnews, Afterimage* and *History of Photography.* In 1991, she curated the traveling exhibition, "Camera as Weapon: Worker Photography Between the Wars." Ollman is the recipient of a Reva and David Logan Grant in Support of New Writing in Photography. She lives in San Diego.

MICHAEL READ, former editor of see and a staff member of The Friends of Photography for several

Peeter Linnap

years, now indulges his writing and photography pursuits as a freelancer in San Francisco. Read has edited several publications, including *Ancestral Dialogues: The Photographs of Albert Chong* (The Friends of Photography, 1994) and *Ansel Adams: New Light* (The Friends of Photography, 1993).

REBECCA SOLNIT, a Bay Area cultural critic and frequent contributor to see, is the author of *Savage Dreams: Journeys into the Hidden Wars of the American West* (Sierra Club Books, 1994) and *Secret Exhibition: Six California Artists of the Cold War Era* (City Lights, 1991). In 1993, she received a National Endowment for the Arts Fellowship for literature.

JOHN TURNER's interest in self-taught art began in the early 1970s with his photographic documentation of California folk art environments. He is the author of *Howard Finster: Man of Visions* (Knopf, 1989), works for ABC/Disney Television and is curator of twentieth century American folk art at the San Francisco Craft and Folk Art Museum.

JOHN WOOD is a premier historian of early photography. His books include *The Scenic Daguerreotype: Romanticism and Early Photography* (University of Iowa Press, 1995) and *In Primary Light,* winner of the 1993 Iowa Poetry Prize. He holds a dual appointment at McNeese State University as Professor of English and Professor of Photographic History.

Gates Buys Library of Congress Collection

JAN. 1, 2001—Software trillionaire William Gates announced yesterday that his Corbis Corporation has bought all the photographs in the Library of Congress for $500 billion, ending a half-century of federal deficits and putting the finishing touch on Gates' image empire.

The vast federal archive includes the famous Farm Security Administration photographs as well as images by Ansel Adams, Lewis Hine and Timothy O'Sullivan. The acquisition, together with Corbis' recent purchases of Eastman Kodak, Fuji and more than a dozen photofinishing chains, completes the "vertical integration" of the digital image environment that has been Gates' goal since he acquired the Bettmann Archive in 1995.

Much like the vertical integration attempted in the entertainment industry by now-defunct Time-Warner, Gates' hold on all aspects of the image environment will allow him to profit from every digital transaction involving lens-based images. For example, photographers can sell the digital rights to their pictures in exchange for a discount on processing fees, which have risen sharply in the last three years. The image processor then loads the digital scans of the pictures onto the Gates-led Microsoft Network, where they can be downloaded by anyone for a fee. Publishers of books and magazines also pay licensing fees to

Corbis for both stock and news photographs.

In Washington, Republican senators expressed delight that the seemingly elusive search for a balanced budget by the year 2001 had been met ahead of schedule. But Sen. Marc Andreessen, D-Calif., cautioned that the Justice Department would have to investigate the anti-trust ramifications of the sale.

Gates' competitor in the digital imaging environment, a coalition formed from the remaining business units of Agfa, Apple, IBM and Polaroid, said in a prepared statement last night that the Corbis acquisition put Gates in a monopoly position vis-à-vis photography.

"Now that Gates owns virtually all the photographs made in the last 160 years, either outright or in digital form, Americans no longer have any freedom of choice about how they take, process or look at photographs. The Government should step in to insure the free flow of photographic information in the twenty-first century," the coalition's statement said.

The coalition's market share has dwindled in the last year to less than one percent of the imaging market, but it remains the only alternative to the chain of imaging companies and technologies that Gates has built in the last ten years.

The Corbis-Microsoft alliance also

has domina... rapidly grow... optical cable ... replacing traditio... the primary mean... cans receive televis... reportedly has held ... NBC, ABC and Fox, ...e major television networks, about purchasing the digital rights to their television series, going back to *I Love Lucy* and *The Steve Allen Show*. He reportedly is also interested in acquiring the large libraries of Hollywood films that the networks now own.

Were Gates to include television and film in his conglomerate of imaging technologies, he would control the rights to a large share of moving pictures as well as still photographs. Whether that would mean that Hollywood producers would need to join the Microsoft Network, paying it a fee to distribute their movies electronically, remains to be seen.

What is clear in the wake of the Library of Congress purchase is that even casual sharpshooters now must interface with the Gates image empire if they are to see the results of their picture-taking. In addition, since Corbis now holds the copyrights for 99 percent of the photographs taken in the two previous centuries, anyone looking at pictures in any place other than a museum probably owes Bill Gates a nickel or two.

Gates Buys Bettmann Collection

The New York Times

OCT. 10, 1995—William Gates, the software bilionaire and champion of 21st-century technology, has purchased the Bettman Archive, whose millions of historical photographs are a visual chronicle of the 20th century.

For the last few years, Gates has been acquiring the electronic rights to thousands of images—mainly works of art—through a small company in Bellvue, Wash., that he owns. But the purchase of Bettmann is by far his biggest step toward building a huge library of digitally stored images that can someday be sampled and sold on computer disks or over computer networks, not only to professionals but to the public as well.

The Bettmann acquistion is a part of the trend of converting the images of art works and texts of the past into the digital code of computers.

see 72

see ISSUE 2:1 →

CONTRIBUTORS

BOBBY NEEL **ADAMS**

CHRISTOPHER **BROWN**

DAVID **CHANDLER**

KEN **COUPLAND**

JAMES **CRUMP**

TODD **GRAY**

LEJAREN À **HILLER**

EUGENIA PARRY **JANIS**

TOBEY **KAPLAN**

DAVID **LEVI STRAUSS**

EVE **LINNAP**

PEETER **LINNAP**

C.T. **McCLUSKY**

DOUGLAS R. **NICKEL**

LEAH **OLLMAN**

MICHAEL **READ**

REBECCA **SOLNIT**

JOHN **TURNER**

JOHN **WOOD**

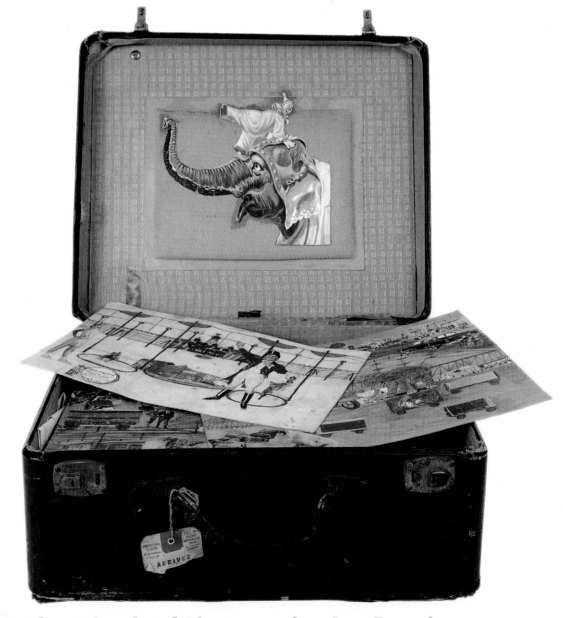

This page: C.T. McClusky's trunk.

Cover: Photographer unknown, portraits of victims of the Khmer Rouge, taken in the mid-1970s at S-21, a prison in Phnom Penh, Cambodia.

The Friends of Photography, San Francisco

see: A journal of visual culture
Issue 2:1

Editor in Chief
Andy Grundberg

Executive Editor
Deborah Klochko

Senior Editors
Steven Jenkins
Amy Howorth

Production Editor
Charlene Rule

Design
Toki Design

Editorial Board

Annie Barrows	Marvin Heiferman
May Castleberry	Howard Junker
Merry Foresta	Carole Kismaric
Jonathan Galassi	Constance Sullivan

Proofreaders
Danielle Gold
Gustavus Kundahl
Grace Loh

Business Manager
Lisa Robb

Subscriptions Manager
Heather Tissue

Accounting Services
Winona Reyes

see is published by The Friends of Photography

ISSN 1076-4550, ISBN 0-262-56101-8

see is a benefit of membership in The Friends of Photography, a national nonprofit organization that
serves as a forum for the intersection of images and ideas, promoting visual literacy through programs of
exhibitions, education, publications and awards. Membership is open to all; for information, write:
Membership, The Friends of Photography, 250 Fourth Street, San Francisco CA 94103, or call 415.495.7000.

see also is distributed worldwide by MIT Press, Cambridge, Massachusetts and London, England.
Second class postage paid at San Francisco, CA, and additional mailing offices.
Printed in Hong Kong by C & C Offset Printing Co., Ltd.

Editorial and 250 Fourth Street
advertising address: San Francisco CA 94103
phone: 415.495.7000
fax: 415.495.8517
E-mail: seefop@aol.com

The Friends of Photography
Andy Grundberg, Director
Deborah Klochko, Deputy Director for Public Programs
Barbara Alvarez, Director of Development and Marketing
Lisa Robb, Director of Operations and Administration

Public Programs	Development and Marketing	Administration	The Friends of Photography
Julia Brashares	Carrie Mahan	Pam Allen	Bookstore
Joanne Chan	Heather Tissue	David Bebb	Charles Hartman, Manager
Elizabeth Dranitzke		Denyse Jones	Sharon Collins
Alcina Horstman		Betsy Pauley	Sarah Kremer
Amy Howorth		Winona Reyes	
Steven Jenkins			
Charlene Rule			

The publication of see is made possible with the primary support of the members of The Friends of
Photography, and Grants for the Arts of the City of San Francisco.

The Friends of Photography extends its gratitude and appreciation to the following Charter Supporters
who have made generous donations to support the publication of see for 1996:

Robert Beskangy	Esmeralda T. Gibson	Jackie & Howard Nemerovski
Keith F. Bevan	Lowell Gimbel	David L. Parman
Edna Bullock	Robert M. Greber	John Pfahl & Bonnie Gordon
Christie's	Richard Hamburger	Todd D. Pierce
Mark Coppos	W.M. Hunt/Dancing Bear	David & Victoria Ruderman
Dr. & Mrs. Alan R. Dimmick	Sid & Audrey Jenkins	Robert & Penny Smith
Michael W. Dimmick	Mr. & Mrs. Richard Laster	Hal Sox
Bryce Douglas	Jaqueline Leventhal	Mr. & Mrs. Peter M. Wach
Stanley Friedman	David C. Matthews	
David H. Gibson	Mrs. R.B. McEachern	